Dedalus Europe 2000
General Editor: Mike Mitchell

The Adventures of the Ingenious Alfanhuí

D1479143

Rafael Sánchez Ferlosio

The Adventures of the Ingenious Alfanhuí

Translated by Margaret Jull Costa

Dedalus

Published in the UK by Dedalus Ltd, Langford Lodge, St Judith's Lane, Sawtry, Cambs, PE17 5XE
email: DedalusLimited@compuserve.com

ISBN 1 873982 59 3

Dedalus is distributed in the United States by SCB Distributors, 15608 South New Century Drive, Gardena, California 90248
email: info @scbdistributors.com web site: www.scbdistributors.com

Dedalus is distributed in Australia & New Zealand by Peribo Pty Ltd, 58 Beaumont Road, Mount Kuring-gai N.S.W. 2080
email: peribo@bigpond.com

Dedalus is distributed in Canada by Marginal Distribution, Unit 102, 277 George Street North, Peterborough, Ontario, KJ9 3G9
email: marginal@ptbo.igs.net web site: www.marginal.com

Dedalus is distributed in Italy by Apeiron Editoria & Distribuzione, Localita Pantano, 00060 Sant'Oreste (Roma)
email: apeironeditori@hotmail.com

First published by Dedalus in 2000
Copyright © Rafael Sánchez Ferlosio 1951
Translation copyright © Margaret Jull Costa 2000

The right of Rafael Sánchez Ferlosio to be identified as the author and Margaret Jull Costa to be identified as the translator of this work has been asserted by them in accordance with the Copyright, Designs and Patents Act, 1988.

Typeset by RefineCatch Ltd, Bungay, Suffolk
Printed in Finland by WS Bookwell

A C.I.P. listing for this book is available on request.

THE AUTHOR

Rafael Sánchez Ferlosio, the son of a Spanish father and an Italian mother, was born in Rome in 1927. This, his first novel, *The Adventures of the Ingenious Alfanhuí*, was published in 1952. His second novel, *El Jarama* (1956), won the National Prize for Literature. Since their publication, both have acquired the status of classics in Spain. He has written two other novels, *El escudo de Jotán* (1983) and *El testimonio de Yarfoz* (1985), books of essays on linguistics, history and philosophy, as well as collections of what he calls 'pecios' or 'flotsam': thoughts, memories, descriptions, aphorisms, poems. He has always been a fiercely original writer and thinker and he remains one of Spain's most celebrated and admired novelists.

THE TRANSLATOR

Margaret Jull Costa has translated many novels and short stories by Portuguese, Spanish and Latin American writers. She was joint winner of the 1992 Portuguese Translation Prize for her version of Fernando Pessoa's *The Book of Disquiet*. With Javier Marías, she won the 1997 International IMPAC Dublin Literary Award for *A Heart So White* and, in 2000, she won the Weidenfeld Prize for her translation of José Saramago's *All the Names*.

7861

'I sowed wild oats along the banks of the Henares.'

The wild ideas that were in my head
and found such fertile ground in
Castile were all sown for you.
This Castilian story, full of true lies,
was written for you.

The eye is the lamp of the body. So, if your eye is clear, your whole body will be full of light.

Matthew 6:22

PART ONE

I

*Concerning a weathercock who caught some lizards and
the uses to which these were put by a little boy*

One night, a weathercock, cut out of a sheet of
metal, and which stands, fixed, sideways on to the
wind and has but a single eye which can be seen from
either side, came down from the roof of the house
and started searching among the stones for lizards. It
was a moonlit night, and the weathercock pecked the
lizards to death with its iron beak. It hung them up
on nails in staggered rows on the white, windowless
wall that faces east. It put the larger ones on the top
row and the smaller ones on the bottom row. The
lizards, though freshly dead, were nonetheless
embarrassed, because the little gland that secretes
the red of blushes or rather the yellow of embar-
rassment – for lizards turn cold and yellow when
embarrassed – had not yet dried up.

But as time passed, the lizards were parched by
the sun, they turned a blackish colour, and their skin
shrank and shrivelled. Their tails bent towards the
south because that side of the lizards shrank more in
the sun than the side that faced north where the sun
never goes. And thus the lizards ended up looking
like scorpions, all leaning in one direction, and now
that their skin had lost colour and firmness, they
were no longer embarrassed.

And after still more time had passed, the rains

came and beat against the wall where they were hanging, drenching them and washing out of their skins a liquid like dark green rust, which trickled down the wall to the ground. A boy placed a tin can beneath each trail and, by the time the rains were over, he had filled each of those tin cans with liquid which he then placed in a basin to dry.

Everything had been drained out of the lizards by then, and when the days of sun returned, all you could see along the wall were a few small, white skeletons covered in a fine, transparent film, like the sloughed skins of snakes, barely visible against the whitewashed wall.

But the boy had more fellow feeling for the lizards than for the weathercock and, one windless day when the weathercock could not defend itself, he climbed up on to the roof, pulled the weathercock down, threw it in the furnace and started working the bellows. The cockerel creaked amongst the charred logs as if still turning in the wind, and it changed from red to yellow to white. When it realised it was beginning to melt, it bent over and, with all its remaining strength, embraced a large lump of coal in order not to be entirely lost. The boy stopped working the bellows and threw a bucket of water over the fire, which went out with a hiss like a cat, and the weathercock remained clasped for ever to that piece of coal.

The boy went back to his basin and saw that, left in the bottom, there was a brown sediment, like fine clay. Over the days, the water had evaporated in the heat, leaving only dust. The boy separated out the grains and made a pile of them on a white

handkerchief in order to study the colour. And he saw that the dust was made up of four colours: black, green, blue and gold. So he took a piece of silk and sifted out the finest grains, which was the gold; then he sifted the blue through a piece of linen and the green through a sieve, leaving only the black.

Of the four, he used the first, the gold, to gild doorhandles; he used the second, the blue, to fill a tiny hourglass; the third, the green, he gave to his mother to dye lace curtains, and the fourth, the black, he used to learn how to write.

His mother was thrilled by her son's ingenuity and, as a reward, she sent him to school. All his classmates envied him his ink because it was so bright and pretty, with a sepia tone none of them had ever seen before. However, the boy learned a strange alphabet that no one else understood and he had to leave the school because the teacher said he was setting a bad example. His mother shut him up in a room with a pen, an inkwell and paper and told him she wouldn't let him out until he had learned to write like everyone else. But once he was alone, the boy got out his inkwell and started writing in his strange alphabet on a torn scrap of white shirt he had found hanging from a tree.

II

*Where we learn how the boy escaped from his room and
about his adventure*

That room was the ugliest in the house, and the
weathercock had ended up there too, still clasping
its piece of coal. One day, the boy started talking
to the weathercock, and the poor cockerel, its mouth
all twisted, told him it knew many things and that,
if the boy set it free, it would teach him those
things. So they made their peace, and the boy
removed the piece of coal and straightened the cock-
erel out. And they talked all day and all night, and
the cockerel, who was older, taught the boy all it
knew, and the boy wrote everything down on the
scrap of shirt. When his mother came in, the cockerel
would hide because they did not want her to know
that a weathercock could speak.

From his position at the top of the house, the
cockerel had learned that the red of sunsets was a
kind of blood that flowed along the horizon at that
hour in order to ripen the fruit, especially apples,
peaches and almonds. This was what the boy liked
most of the many things the cockerel was teaching
him, and he pondered how he could collect some of
that blood and what he could do with it.

On a day which the cockerel deemed to be right,
the boy took the sheets from his bed, as well as three
copper pots, and ran off with the cockerel towards

17

the horizon they could see from the window. They reached an empty plateau, on the edge of which was the distant horizon that could be seen from the house, then they waited for the sun to go down and for the blood to flow.

They watched the gradual approach of a pink cloud, then a reddish mist enfolded them, and there was an acrid smell of iodine and lemons. Finally, the mist turned entirely red and all they could see was that extraordinarily dense light, halfway between carmine and scarlet. Now and then a lighter tone would appear, green or gold. The mist grew redder and redder, darker and thicker, shutting out the light, until they found themselves plunged into a scarlet night. The mist began to exude at first a kind of dampness and then a very fine, light, scattered drizzle that soaked and reddened everything. The boy picked up the sheets and began waving them about in the air until they were completely red. Then he wrung them out in the copper pots and once more waved them about in the air until they were again drenched. And he repeated this until the three pots were full.

The mist was now a reddish black, veined with blue. The bitter, musky smell was becoming transformed into a lighter smell, suggestive of animal violets. The light began to grow brighter again, and the mist took on a bruised, purple tinge because the blue streaks had mingled with the red. The dampness diminished and the mist gradually cleared. The smell like animal violets became more subtle and plant-like. The mist was thinning and becoming an

increasingly pale bluish pink, until, finally, it lifted completely and they could see again. Up above, the sky was white and cloudless, and the air was filled by the perfume of lime blossom and white roses. Below, they could see the sun sinking, bearing away with it the scarlet and carmine mists. It was growing dark. The three pots were full of the thick, red, almost black blood. It was boiling, sending up large, slow bubbles that burst noiselessly like blown kisses.

That night they slept in a cave, and the following morning, they washed the sheets in a river. The water in the river became stained with red, ripening and corrupting everything it touched. A pregnant mare drank from the river and turned completely white and transparent because all her blood and colour went straight to her foetus, which could clearly be seen inside her womb, as if inside a bell jar. The mare lay down on the green grass and expelled the foetus. Then she got up and walked slowly away. It was as if she were made of glass, with a white skeleton revealed underneath. The brilliantly coloured foetus, deposited on the short grass, was contained in a bag of water which was covered in a network of fine green and red veins that flowed into a purple cord out of which the liquid was slowly seeping. The little horse was fully formed. It had a chestnut coat and a large head and prominent eyes surrounded by perfect eyelashes; it had a taut belly and slender legs that ended in hooves made of cartilage that was still soft; its mane and tail floated in the mucous, syrupy liquid inside the bag. It was as if the little horse were floating in a goldfish bowl, moving very slightly. The

weathercock pecked through the bag with its beak, and all the water spilled out onto the grass. The foal, which was about the size of a cat, gradually awoke, as if stretching, and then got to its feet. It was entirely made of dense, vivid colours, such as had never been seen before, the mare's colours having been entirely absorbed into that small body. The foal raced off in search of its mother. The mare lay down to suckle it. The milk ran white through her glass teats.

The boy and the weathercock returned home. They took the copper pots with them and climbed in through a balcony window. Then they poured the blood into a large earthenware jar and sealed it. The mother forgave her son, but the boy said that he wanted to be a taxidermist and so he was sent as apprentice to a master of that trade.

III

How the little boy went to Guadalajara and received the name 'Alfanhuí', and the things and the people to be found in his master's house

The master taxidermist lived in Guadalajara. The boy went to Guadalajara and looked for his house. The taxidermist lived down a vaulted, windowless passageway which was lit by oil lamps hung from the walls. All along one wall of the passageway was a large workbench and on it all kinds of iron, wooden and brass tools. There were two low doors in the passageway, and the passageway itself ended in a rather small octagonal room that was lit by a green skylight in the roof.

The master gravely looked the boy up and down and said:

'You have yellow eyes like a stone curlew's, so I'll name you Alfanhuí because that is the name the stone curlews call to each other. Do you know anything about colours?'

'Yes, I do.'

'What do you know?'

The boy told him what he had done with the rust from the lizards, but said nothing about the blood because the weathercock had told him to keep it a secret, since he was the first person ever to have collected it.

21

'Very good,' said the master.

The master opened one of the doors to reveal a small room with, at the far end, a little stained-glass window made of unevenly cut bits of glass soldered together. The walls were lined halfway up with dark walnut. The high, narrow bedstead had a golden ball at each of its four corners. On each ball was a bird: guarding the head of the bed, to the right and the left, were a blackbird and a bee-eater; at the foot were a curlew and a lapwing. There were many other birds in the room too, notably a heron.

'This is where you will sleep,' said the master.

Also living in the house was a maid, sombrely dressed and lacking a name because she was a deaf-mute. She moved about on a plank set on four wooden wheels, and, although she was stuffed, she did occasionally smile.

There was a small garden at the front and to the side of the house. It was separated from the street by a low wooden fence, painted green.

The master used to tell stories long into the night. When he began to tell them, the maid would light the fire. The maid knew all the stories and would stoke up the fire as the story began to build. When it became monotonous, she would let the fire die down and, at moments of excitement, she would put on more wood until the story ended and she allowed the fire to go out.

One night, the firewood came to an end before the story did, and the master could not go on.

'Forgive me, Alfanhuí.'

He said and went off to bed. He only ever told stories by the fire and, during the day, he barely spoke.

IV

*Which describes a nocturnal adventure and the maid's
illnesses*

Underneath the house was a damp, square cellar.
On its four walls hung assorted animal parts: legs,
heads, wings, beaks, tails, horns, hooves, etc., rem-
nants left over from the taxidermist's work. And that
was all.

One night, a white cat got into the house and
slipped into the cellar. It began to wander around in
the dark and was unable to find its way out again. It
began climbing up one of the walls and bumped into
the first of those remnants. When it felt the touch of
feathers, it miaowed and hissed so loudly that it
woke both the master and Alfanhuí. They went down
to the cellar with a lantern and found the cat carry-
ing in its mouth a swan's neck, head and all. The
swan's neck writhed about as if it were still alive and
it kept pecking at the cat's forehead because the cat
had fastened its teeth in the tendons and was too
frightened to let go. The cat kept leaping up at the
walls, making yellow sparks as its claws scraped on
the stones. The master called for the maid to catch
the cat. He carried her down to the cellar because she
could not get down there alone on her wheels. The
maid immediately picked up the cat, which dropped
the swan's neck and bit the maid on the wrist. The
wrist crackled like parchment, but the maid was

25

quite unmoved. The master picked the maid up in his arms again and carried her upstairs. They all went back to bed, and the maid retired still clutching the cat, which struggled all night. By the following morning, the maid was in tatters. The skin on her arms, chest and neck was scratched and torn, and the stuffing was coming out.

From the cat they made cords for clocks with weights, from its claws an implement for combing fur, from its skeleton a little cage for mice, and they used its skin to make a little drum and to patch up the maid. The master restuffed the maid with cotton and covered the holes with fresh cat skin, curing the patches *in situ* on the maid's body. Of what remained of the cat, they stuffed only the head and exhibited it in the window.

The patches on the maid dried quickly, and she was soon well again. On another day, though, they left her out in the rain and she went all soggy. She recovered from that too, but was left somewhat drier and more shrunken. Some time later, she caught jaundice and turned completely green.

Thus the maid went from illness to illness until, one day, she died. Alfanhuí and his master buried her in the garden with a headstone etched in vinegar saying:

SELFLESS AND SILENT

V

*How Alfanhuí came to light the fire and the long story
told him by his master*

After the maid died, the fire was not lit again. The
master grew sad, and Alfanhuí did not dare say any-
thing. But one day, he looked at his master almost
coolly and asked him:

'Would you like me to light the fire, master?'

At first, the master was somewhat taken aback,
but then he said that he would. Alfanhuí knew about
firewood. He knew which kinds of wood gave off sad
flames and which gave off joyful flames, those that
made strong, dark fires or those that made bright,
dancing fires, those that left female embers to warm
the dreams of cats or others that left male embers to
bring repose to hunting dogs. Alfanhuí had learned
about firewood in his mother's house, where they
also used to light a fire, and he knew that his master's
fire was like the fire of his maternal aunts and uncles,
of the travellers who used to arrive all dressed in
grey. So Alfanhuí brought an armful of carefully
chosen pieces of wood and started lighting the fire.
The master observed him from his chair. He watched
Alfanhuí crouched in front of the fireplace, concen-
trating on his work, he saw his calm, cold, stone
curlew eyes and, at last, he saw Alfanhuí's first flame
leap up, bright and joyful, and his eyes shone and a
smile appeared on his lips. Then he said:

'I never dreamed, Alfanhuí, that you would turn out to be such good company. In payment for your first fire, Alfanhuí, I will tell you my first story.'

He enjoyed repeating the name 'Alfanhuí' because he had chosen it. Then he began the story.

'When I was a boy, Alfanhuí, my father used to make oil lamps. He would work all day and make iron lamps for country cabins and brass lamps for palaces. He made thousands and thousands of different lamps. He also owned all the best books ever written about lamps. One of them spoke of a "veined stone". This was a stone the size of an egg and the shape of an almond and which was said to be both extremely hard and yet as porous as a sponge. This stone was capable of soaking up seven large jars' worth of oil. You left it in a jar and the following morning all the oil would have disappeared, but the stone remained the same size. When it had drunk seven jars' worth of oil, it did not want any more. Then all you had to do was attach a wick, light it, and the flame would burn for ever, though you could blow it out if you wanted. But if you ever needed to get at the oil again, that was something only a barn owl could do, leaving the stone as dry as it started. My father was always talking about this stone, and he would have given anything in the world to own it. My father used to send me off along the roads and paths in order to learn about the different colours of things, and I would often be away for days at a time.

One day, I set off on just such a journey. I carried a stick over my shoulder with, on the end of it, my lunch wrapped up in a handkerchief. I was walking

28

along a limestone path through dusty, grassless hills with only a few wizened trees on which the magpies perched. Strewn about the countryside, there were also many hollows full of rags and broken earthenware pots and wheels and the wreckage of carts and all kinds of rubbish, because people used that land as a dumping ground for anything broken. There was hardly anyone else on the path as it was an extremely hot day and the sun there was very fierce, even though it was not yet summer.

In the distance, I saw a figure sitting on a stone by the path. When I reached him, I saw that he was a beggar, and he said to me: "Give me some of your lunch."

He made room for me on the stone, and we started eating. Then I got a better look at him. He was wearing dark trousers that came to mid-calf level and a brown waistcoat that revealed his bare shoulders and arms. But his flesh was like the earth in the fields. It had the same form and colour. Instead of hair, he had thick clumps of moss, and on the crown of his head was a lark's nest with two chicks in it. The mother bird kept fluttering about above him. His beard was made of the finest grass, sprinkled with daisies the size of pinheads. The backs of his hands were also covered in flowers. His feet were prairies out of which sprang dwarf honeysuckles that climbed up his legs as if up strong trees. Hanging over his shoulder he had a strange flute.

He was a sturdy, jolly beggar and he told me that the reason his flesh germinated like that was because of all the walking he did, because of all the sun and

29

rain that fell on him and because he had never lived in a house. He told me that in winter, moss and other protective plants grew all over his body, as it did on his head, but that when spring came, the moss dried up and the plants fell away to make room for the grass and the daisies. Then he explained about his flute. It was the opposite of other flutes and had to be played in the midst of great noise, because rather than silence being the background and noise the tune, as was the case with other flutes, with his flute, noise was the background and silence provided the melody. He used to play it in the middle of great storms, amid thunderbolts and downpours, and from it emerged silent notes, fine and light as threads of mist. And he was never afraid of anything.

I spent the afternoon and evening talking to him, and night overtook us. The beggar invited me to sleep where he slept, in the hollow trunk of a tree. We walked for a while to get there. It was a large tree and inside were many things I could not quite make out. The trunk itself was very tall and rose up in the shape of a cone, and the wood inside formed groined vaults, like the gills on the underside of mushrooms. Up above, you could see the night growing blue with stars.

The beggar lit a lamp, and I saw a tiny, bright flame. It was the veined stone. Then I told him how my father had always wanted to find that stone, and the beggar, who was a generous man, gave it to me. I could hardly sleep that night and, the following morning, I took the path back home. I reached my house, shouting: "Father! Father!"

But when I went into my father's bedroom, I saw that he was dead. Everyone was gathered around him, still and silent. They did not even look up when I came in. My father was lying on a table, wrapped in a white cloth which left only his face uncovered. His mouth gaped open like an old fish, and the light from the four oil lamps glinted in the glassy crack of his half-open eyes. I turned away and went and wept with my face pressed into a purple curtain that used to hang in my house, and which was the curtain where I always went to cry.'

The master looked at the fire that Alfanhuí had lit for him. Then he went on:

'Some days after they had buried him, I chose the prettiest lamp I could find and I prepared the veined stone in order to take it to the cemetery.

My father was sleeping in a cave beneath the earth, inside a glass-lidded coffin. I slipped in unseen and hung the lamp on the wall at the head of the coffin. Then I lit the wick on the stone with the other lamp I had brought and I gazed at my father's face by the light of the little white flame.'

The master fell silent and looked at Alfanhuí, who was sitting on the floor by the fireplace. The fire was only embers now. The master got up from his chair and went to bed. Alfanhuí remained by the fireside, thinking and poking about in the burned-out logs with a stick.

VI

Concerning the things that were in the garden of the moon, where almost everything resembled silver

The garden belonging to the house had two parts, the garden of the sun and the garden of the moon. The former was on the south front. The latter on the east side and this was the garden onto which Alfanhuí's little window looked out. Alfanhuí preferred the garden of the moon because his own skin was white as moonlight. On moonlit nights, he would sit on the window ledge and gaze out at the garden.

In the garden were a chestnut tree and a silver-leaved olive tree with a sinewy trunk in which lived two white rodents with luminous eyes and which were always hiding away like squirrels. At night, you could see their little eyes appear and disappear. They were like the neon signs found in cities: first one light, then two, then three, then four. Three, two, one and they were gone. Then four little lights would come on at once in some other part of the olive tree. And so it went on all night, with never a sound being heard. Alfanhuí used to sit watching the garden and the rodents' games until the moon went down.

There was also a white milestone in the garden with a ring set in it and a black chain that sprawled on the ground. In the middle of the garden was a small round pond with a thin jet of water that rose, wavering, into the air on hot, sultry nights, and

killed the dragonflies and other insects that the wind brought with it from the dried-up rivers and lakes. And when the surface of the pond rippled, making tiny waves, the glimmer from the silver sands that lay on the bottom would rise to the surface. The maid was buried in another corner of the garden. At the back was a high wall and an abandoned greenhouse with dusty windows. The greenhouse was overgrown with weeds and in it lived a silver snake which used to go out to take the moonlight in a clearing in the garden. Alfanhuí really liked that snake and decided to capture it.

Alfanhuí knew that, like oranges and lemons, silver and gold formed a natural pair, and he had the idea of making three small gold rings, slightly larger than the circumference of the snake's belly. He tied a long piece of thread to each ring and waited for the full moon.

One night, as it grew dark, he put the rings in place: the first one outside the hole from which the snake would emerge, the second a little further on and the third in the middle of the clearing where the snake used to bathe in the moonlight. With the three pieces of thread in his hand, Alfanhuí positioned himself carefully by the window, inside his room, and waited. A large red moon rose up from the horizon, growing whiter as it did so. Alfanhuí stood absolutely still. When the moon was completely white, the snake stuck its head out of the hole and through the first ring. Then it gradually slithered forth, looking all around, its head high, its forked tongue darting in and out. Alfanhuí remained absolutely still. It

slipped inside the first ring, but the ring did not move, and only when the snake made a first sinuous S with its body did the ring shift down to the middle of its belly. Alfanhuí did not even dare to breathe. With the second S, the snake went through the second ring and carried it onward as it had the first. Then, finally, it slipped through the third ring. Alfanhuí was watching, motionless, from the window, holding the three pieces of thread. The snake stopped and the three rings, threaded onto its body, joined together in the thickest part of its belly. They grew tighter as they touched and squeezed the snake, as if embracing it about the waist, and the snake was caught. Alfanhuí tugged gently on the three pieces of thread and dragged the snake over to the window. The silver snake fell blissfully asleep in the embrace of the three gold rings. Without removing the rings, Alfanhuí coiled the snake up inside a round glass box, and the snake, as hard and bright as silver, did not wake up. Its body was covered in tiny scales that made a noise when Alfanhuí ran his finger over them against the grain: Rrrring! Rrrring!

Alfanhuí untied the three silk threads and closed the glass box. The moon coming in through the half-open window fell on Alfanhuí's face. He looked down at the snake in his hands and smiled. Then he put the box away in the dark and went to bed.

VII

Concerning a wind that entered Alfanhuí's bedroom one night and the visions that Alfanhuí had

One rainy night, a distant wind blew into the garden. Alfanhuí had his window open, and the wind made the flame of his lamp flicker. The shadows of the birds trembled on the walls. They moved only slightly and hesitantly at first, as if they had been woken unexpectedly. From his bed, Alfanhuí saw the shadows trembling on the walls and the ceiling, and saw how they fragmented and overlapped in the corners of the room. It seemed to him that his little room was getting larger and larger until it had become a vast salon. As the little flame in the oil lamp flickered, the shadows of the birds were growing larger too and more numerous. The wind was blowing more forcefully in through the window and brought with it something like the music of rivers and forgotten forests.

The flame made the shadows dance to that music. Like ghosts or puppet birds they began dancing the arcane dances, the primitive dances of their species, tracing on the high ceiling of the salon a great ring of wings and beaks, a constantly changing ring, light and luminous, that turned and turned, restoring to the dead shadows the birds' former colours. In the middle danced the heron with the Chinese eyes, moving its beak to a haughty rhythm, keeping time

for all the other birds, and the wind seemed to be hurling gusts of rain into its eyes. The stuffed birds had vanished from their pedestals, as if the rain had brought them back to life, and they had flown off to join their shadows dancing on the ceiling of the salon.

The fog of silence and solitude vanished, and forgotten visions awoke as the music of the wind and the rain met the dead colours of the birds. In the middle of the ring of birds on the ceiling, a circle seemed to open up to which all the primitive colours were returning. The thousand greens of the jungles, the white of waterfalls and, from the land of wading birds, the pink and grey of the wetlands, with a red sun trembling on the muddy, bloodshot surface. At the foot of the purples and yellows of the reedbed gleamed the black silt of the banks, carpeted with tiny roots that snaked about amongst the myriad tracks left by different birds. The salty whites of the estuaries returned, along with the saltmarsh birds who probe the mudflats with their long beaks. And the marine sun of the seagulls and the albatrosses beat down on a desert of sand and conch shells. The blue of the cities of the land came back, as well as the swallows threading through the arches of the towers, stitching belfry to belfry with the threads of their flight. The wind also blew open a book of dried flowers and began leafing through it. The flowers grew moist again and revived, climbing the walls of the salon, invading everything, forming a dense, flowering arbour full of nests from which more birds emerged and immediately flew up to join the luminous circle on the ceiling.

Alfanhuí would have been unable to say whether there was a dark solitude in his eyes and an unfathomable silence in his ears because the music and the colours came from that other place from which concrete knowledge never comes, a place abandoned on the very first day behind the farthermost wall of memory where that other memory is born: the vast memory of things unknown.

The birds danced and danced the primitive dances of their species, and once more there was that intermingling of flocks flying towards the sacred rivers – to the Euphrates, to the Nile, to the Ganges, to those Chinese rivers named after colours – once more the whole migrant, multicoloured geography of birds, the light of ancient lands.

Then the luminous circle of visions vanished, and the dance of the shadows returned to the walls, obscure and agitated this time, like a witches' dance, moving to the dull thud of a distant drum, a dance by stiff ghosts with gangling legs. Faster and faster they danced; the salon walls were closing in again, the room pressing in around Alfanhuí's head. The dance and the shadows shrank smaller and smaller around the flame of the lamp. The shadows returned like grey butterflies singeing the dust on their wings. It was the dust from the birds' dry feathers, and, for a moment, the infinitesimal motes glowed incandescent, repeating, as they burned, each of the bright, distant colours in the visions, only to be lost again in the small, simple light of the lamp. Everything once more withdrew into itself. The wind had dropped. The shadows were dying, once more

39

motionless on the grey walls; the birds were dying in the empty glint of their glass eyes, and the final drop of oil rose up to the exhausted flame, expiring on the threads of the wick. The flame sputtered out with the last dust motes and was soon nothing more than a smoking cinder, barely glowing, in the brass lamp. The dark, moribund smell of burnt oil hung in the air, and everything went dark. There was now a light silence that seemed to be waiting for a clear, solitary voice, for a song greeting the dawn or for the footsteps of hunters.

VIII

*In which the contents of the attic are described, as well
as how Alfanhuí fell asleep*

The attic was reached by a short spiral staircase. A
shaft of sun came in through the dusty glass of the
skylight. It fell diagonally and was starred with dust
motes wandering aimlessly about in the air. It was
very hot in the shadows up there, and you could hear
the creak of the scorched rooftiles expanding. The
attic smelled musty and was full of sleep. Alfanhuí
felt a rain of dust falling on his eyelashes like an
invisible snowfall. On the wooden floor was the dried-
up puddle left by a leak. It was like a lake bed in
summer and it contained the reddish mud from the
dust of the tiles that the leak had been wearing away
on the roof, gathering there like a fine, miniature
alluvium. The little puddle had dried up beneath the
shaft of light from the window, and on its undulating
shores you could see the different levels reached by
the water in years of heavy or little rainfall. In the
middle of the puddle stood a chair, its four legs
slightly sunk in the mud. It was a chair made of
highly polished cherry wood, liquid red in colour, like
Bordeaux wine. Its four legs had put down roots in
the alluvial soil from the roof tiles, and the roots
reached down to the bottom of the little lake, inter-
secting each other like a spider's web, greedy for
every drop of the small amount of water that fell

there. The chair faced the window, greedy too for the shaft of sunlight, and the sun trembled in the grain of its wood as if real blood flowed through the frame of the chair. The whole chair had a sleepy, abandoned air, as if the only voice it ever heard was the muffled, external cry of some bird perched on the dusty skylight. You could see its silhouette from the attic, blurred by the drops of rain written on the glass; but no one ever saw from the roof what was inside the attic. From the two uprights on the back of the chair sprang a few green branches and some cherries. The cherries were ripe and covered in dust, but on their convex surface they reflected in miniature everything in the attic. Four pairs of small, dark cherries rested gaily on the green leaves.

Alfanhuí sat down on the chair and placed his head between the two branches of the cherry tree, which circled his forehead like a crown, and the cherries seemed to hang from his ears like earrings made from dark rubies, red against his chestnut-brown hair. Through the window, Alfanhuí could see the sky and the golden sun of the siesta hour. He closed his eyes and – projected onto the translucent film of his eyelids – he saw flickering lights with insistent patterns that the sun had left in the depths of his pupils. But the snowstorm of dust kept falling and falling on his eyelashes, and Alfanhuí dropped asleep.

IX

Concerning two men who were in the hayloft

When Alfanhuí woke up, it was already night. The moon was not yet shining in through the skylight, and everything was very dark. Alfanhuí looked around him and saw on the floor, by the wall, a slender line of tenuous, golden light. It was the door that led into the upper part of the barn and which he had not noticed before. A low murmur came from within. Alfanhuí quietly got up from the chair and opened the door. He saw an elongated hayloft, crammed to the rafters with two piles of straw and with only a narrow passageway between them. To the rear, in the angle formed by the two sloping sides of the roof, was a tiny window through which the bats came and went. But the light he had seen came from floor level, from a small lantern with four glass sides that cast an intense golden light on the straw. Two men were sitting on the floor by the lantern, bent over a large white handkerchief, as if they were playing cards. Alfanhuí stood by the door for a while watching the scene. The men were talking in low voices and seemed to be counting money. Alfanhuí walked down the passageway and stood before them. The two men were swarthy and unshaven. One wore a threadbare beret and the other a black felt hat with a pointed, conical crown. They continued tossing coins onto the handkerchief, and one of them was counting:

43

'One hundred and twenty-three, one hundred and twenty-four . . .'

When Alfanhuí joined them, the one with the hat said, almost without looking up:

'Go away, you mustn't see us.'

And he went on counting. Then Alfanhuí said:

'Who are you?'

'Go away, you mustn't see us.'

'I'm a friend.'

'If you're a friend, then go away; no one must see us because we are thieves.'

'I'm a friend to thieves as well.'

'Not even friends must see thieves when they're in their hide-out.'

'Explain to me what you're doing. I won't tell anyone.'

'We steal wheat; we're counting gold coins; we're always counting; we haven't stolen any wheat for years now, nor left this place for years; this is our hide-out.'

'If you steal wheat, why are you counting gold coins?'

'You exchange wheat for gold and gold for wheat.'

'And why are you here?'

'We really like this place because it's full of straw and straw is like gold and like wheat; during the day, we stop counting and we sleep.'

'Why don't you go stealing any more?'

'We've got enough money; we stole all this when we were young and we don't need any more, so we just count it every night.'

'What are your names?'

'My name's El Bato and I'm the captain; he's called Faulo and he's dumb, but he can hear a sound from miles away and can see as well as a barn owl at night. More than that, he knows how to whistle round corners so that you can hear the whistle in the next street.'

'And how many coins have you got?'

'We've got an odd number, and I get to keep the extra coin because I'm the captain. That makes Faulo jealous, but he always obeys me.'

El Bato made a space for Alfanhuí on the black cloak he was sitting on and said:

'Sit here.'

Alfanhuí sat down and looked at Faulo. He had tiny, sparkling eyes, as bright as a whistle, and was always looking mischievously about him. The captain wore a grave expression and had a long, gaunt face. He had furtive eyes and, every now and then, he would glance sideways, as if at some invisible object.

A bat flew into a roof beam and dropped onto the handkerchief. Faulo, quick as a flash, slipped his hand under the bat and filched a gold coin. El Bato said:

'Faulo, give me back that coin.'

Faulo took it out of his pocket and gave it back. El Bato turned to Alfanhuí:

'He steals from me every night, but I always see him. Then he gives it back to me and laughs.'

For a long while, the two thieves continued counting their coins in silence, during which one could hear only the murmur of numbers and the flutter of the bats who occasionally flew down to the lantern.

Then it was the turn of the mice. Alfanhuí saw a small mouse run over to the light and sit staring at El Bato and Faulo, apparently surprised to see Alfanhuí there. Then, one by one, other mice drew near, stopping just behind the first mouse, who appeared to be the king of the mice, because all the other mice hung back. El Bato said:

'They're nervous because you're here.'

Alfanhuí moved away, and the mice came closer, as far as El Bato's feet. Then the king of the mice climbed onto the captain's knee, and the captain plucked some grains of wheat from the folds of his trousers and held them in his hand for the mouse to eat. When the king had finished eating, El Bato scattered more wheat grains on the floor for the other mice, who nibbled away quite happily. Faulo did the same with another group of mice who had scurried over to him. There were about thirty in all. When they had finished eating, they disappeared into their various holes in the hayloft. The two thieves resumed their counting, and Alfanhuí watched them silently. Finally, he got to his feet and said:

'I'm going now, my friends.'

El Bato looked him up and down and smiled:

'So you're a friend to thieves, are you? Well, thieves are your friends too. What's your name?'

'Alfanhuí.'

'Goodbye, Alfanhuí.'

'Goodbye.'

Alfanhuí turned round and walked towards the small door. As he was about to open it, he heard El Bato call to him:

'Wait! Come back.'

Alfanhuí went back over to them and the captain held out a gold coin to him:

'Here you are; now we'll have an even number.'

Alfanhuí took the coin and thanked them. Then he went over to the door and left the hayloft. The moon was coming in through the skylight, shining on the cherry-wood chair, on the cherries and on the leaves. Alfanhuí went down the spiral staircase and joined his master for supper. The bell struck ten o'clock.

X

Concerning the things to be found in the garden of the sun and how Alfanhuí climbed down into the well and made many new discoveries

In the garden of the sun, next to the fence, grew an almond tree whose branches reached out into the road beyond. During the summer, a cicada would sit on the bark of the almond tree and sing all through the hours of the siesta. The air would press down so heavily on its song, and indeed on everything else, that no one could move until the cicada at last fell silent. It was the cicada of leaden, sultry days, when watermelons grow rank.

In the garden of the sun, there was also a mill-stone, half-buried at an angle in the ground. Around this stone and through the hole in the middle, the grass grew strong and lush. The wall lizards liked the stone too, for it grew very hot in the sun, and it was so smooth that the master used it to sharpen his knives and tools.

And there was an old balcony rail propped against the wooden lean-to, its palings encrusted with wasps' nests. Outside the front of the house was a row of flowerpots containing geraniums and pinks, which the master tended and watered. Screwed into the yellowing whitewash of the wall were lots of rusty hooks, from some of which hung rags or redundant keys, or wicker cages intended as enticements to

customers, except that they were always empty. There was no glass in the square shopwindow; it was protected instead by a sheet of wire mesh and, to keep the rain out, a small roof made of boards warped by the weather and painted the same pale green as the fence and the shutters.

However, of everything that was in the garden, the well was the most important. It was surrounded by a parapet of green stone and had a wrought-iron arch for the pulley. The pulley was made of wood and chirruped like a swallow in flight. The bucket was wooden too, bound with iron hoops like a barrel, and very heavy. The well was deep and the water in it clear as clear. Halfway down, there was a dark archway that led into a kind of gallery. This so intrigued Alfanhuí that, one day, he took off his shoes and went to the well. He stood in the bucket and lowered himself down, gradually paying out the rope until he reached the gallery. He stepped into the gallery and saw that the water only came to mid-calf level, because the gallery was shallower than the well. Then he let go of the rope, lit the candle he had brought with him, and advanced into the darkness. Under his feet, he could feel a few pebbles on the slippery, mossy bottom. Threads of water ran down the walls which were covered in dank moss inhabited by creatures resembling starfish, only flatter and about the size of a hand. A drop of water extinguished the candle, and Alfanhuí was left in the dark. At the far end of the gallery, he could see a very narrow opening lit by a dim, greenish light. He continued on, and the water grew shallower and

shallower until, finally, he was walking on dry ground. He reached the opening. He only just managed to squeeze through and found himself in a kind of bell-shaped cave, whose walls were lined with thick roots. He realised that this was the base of the chestnut tree. The cave was not particularly large and, in the middle, there was a small pool of greenish water into which dangled a column of long, very fine roots that hung down from the cave roof like a head of hair. Around the pool was a strip of sandy beach that sloped up to the wall, where it touched the thick roots that supported the earth and formed an arch up above, like a cupola. Alfanhuí could not understand where the greenish light filling the cave was coming from. Then he saw a huge spider, the size of a plate, dozing on the sand; it had thick legs and a body that glowed like a lantern. The spider must have been blind, because its legs were evenly spaced around its body, and it was impossible to tell which was the front and which was the back, and neither, apparently, did it have any eyes or even any form of antenna. It was exactly the same all round, and the green light was emanating from the spider's flattened ball of a body.

Alfanhuí noticed that the threads hanging down from the roof were of two kinds. Some siphoned up the green water from the pool and others drew down light from above. But he did not have time to see any more, because the spider woke up and, turning on its own axis, made its way across the small, circular beach until it bumped into Alfanhuí's foot and bit it. When it did so, its light dimmed a little and it

scuttled back into the water like a crab. Alfanhuí realised that the spider was drinking in the light from the descending threads; by then, however, the bite was hurting so much that he left. He walked back down the gallery and climbed out of the well the way he had come. Then he went to find his master in order to tell him everything and to have him take a look at the bite. His foot had turned phosphorescent and he could see his own bones beneath the greenish flesh. After a few days, though, the light faded and went out, leaving his foot unscathed.

Both the master and Alfanhuí considered that they could do great things with his discovery.

XI

In which the master tells the story of the cherrywood chair, and in which he and Alfanhuí carry out the first experiment on the chestnut tree

Alfanhuí and his master talked a great deal during the nights that followed. The master told how he had once eaten a cherry from the chair. It had tasted of nuts, of smoking braziers and candles made from spermaceti, which is what musty rooms and the boredom felt by houses taste like. On the night he ate of its fruit, the master had seen the whole history of the cherry tree in his dreams. The former owner of the house, a cabinetmaker, had planted it in the garden. Some time later, the man had married a very pretty young woman, and he had cut down the cherry tree in order to make her a chair. The young woman used to sit in the chair every evening with her sewing on her lap. But when the cherry tree had been cut down, made into a chair and shut up inside that house, it had still been in the flower of its youth, and now it was sick with boredom. The cherry tree hated four things in that house and they were always there before it: the fringed bedspread made of purple silk that adorned the matrimonial bed, the sewing basket made of wicker and ribbons, a Moorish cushion with a tassel at each corner and, above all, a calendar made of embossed cardboard edged with clouds in Valladolid pink and with a drawing of swans and

gardens in the middle – similar to that in the last square on the board of the Game of the Goose – underneath which was written:

WIDOW RUIPÉREZ
Maker of fine biscuits
Established 1911 Dos Hermanas (Seville)

That is why the cherry-wood chair had grown ill with boredom and was constantly harking back to the happy days when it used to bloom in the garden. And it wanted to have its revenge on the cabinetmaker. Gradually, it began infecting with boredom the woman who sat on it to do her darning. The woman sickened, which is why she had no children and why her skin took on a wax-like quality and her eyes grew dim; until one day, she died of pure boredom, as if she had simply faded away. Ever since then, the chair had been kept in the attic, because the cabinetmaker had taken it up there so as not to have to see it.

And that is the story that the master dreamed when he ate the cherry. He had bought the house after the cabinetmaker died and had found the chair in the attic, exactly as it was now.

Alfanhuí realised that his master too had grown ill with boredom. However, while boredom – which others call the 'indoor sickness' or 'pale apathy' – can prove fatal in women, it is neither fatal nor debilitating in men; rather, it invigorates them and, far from turning them to wax, has the same effect on their flesh as alcohol does on precious woods. Alfanhuí saw this in his master's face – for his face and hands

looked as if they had been carved out of walnut wood, like those of a St Jerome figure carved into the choir stalls – in his serene gaze, his grave, sententious voice and his upright, albeit slow and feeble gait.

In the nights that followed, Alfanhuí and his master pondered the matter of the well and the chestnut tree. The master could not go down into the well to investigate for himself, so Alfanhuí had to describe it all to him exactly. They came to the conclusion that the fine roots hanging from the cave roof were veins from the leaves, and that each vein was attached to a leaf and drew up from the pool the green water that gave the leaf its colour. The descending roots made the journey back, drawing sunlight from the green leaves down into the pool. Each leaf, then, had two such threads. If Alfanhuí removed one of the ascending veins from the water, the leaf it belonged to would gradually drain of colour and become white. The spider was a parasite of the chestnut tree, feeding on the light from the descending veins and drawing it into a mouth in its belly, a round mouth rimmed by lashes. It would lie in the water and get underneath the thinnest of the roots, its mouth uppermost, gripping with its legs and sucking in the light from each vein. This was clearly what was happening, because, whenever the spider was submerged in the water, the whole pool would glow. The thick roots that formed the walls of the cave came from the branches of the chestnut tree, which thus anchored itself in the earth and drew strength from it.

The master prepared various vegetable dyes made

from flower petals or fruit juice to create subtle, innocuous colours which, while they lacked any actual power to fertilise, were not sterile or inimical to the vital force. Then he despatched Alfanhuí with a net to capture the spider and tether it to the walls of the cave. This done, Alfanhuí strung various bits of wire, like washing lines, across the cave, about halfway up the walls. And from the tangle of roots, he selected out all the ascending veins and draped them over the wires so that their tips were out of the water. He then divided them into six equal bunches, because that was the number of colours his master had prepared.

That night, they left the chestnut tree to rest, and, the following morning, all the leaves had gone white and limp. The master and Alfanhuí were overjoyed and set about beginning the experiment proper.

Alfanhuí built a kind of platform or stage, like a broad shelf, at a midpoint around the cave walls. One by one, he carried six wooden basins down to the cave and placed them on the platform, just as his master had told him to. He put the tips of each bunch of roots into a separate basin. He then took the six jugs of coloured liquid down to the cave and poured each one into a different basin.

Alfanhuí then rejoined his master, and they sat together in the garden watching the chestnut tree. After a while, they saw that some of the leaves were beginning to turn orange, whilst the others remained white. They presumed that the orange dye had proved to be the most fluid, which was why its effects were felt first. The violet dye was the next to reach

the leaves. Now there were two colours. Then, by turns, came the blue, the red, the yellow and the black. Within two hours, all the leaves were different colours, and the chestnut tree looked like a marvellous botanical harlequin. Alfanhuí and his master held an impromptu party and decorated the house with colourful branches and garlands.

XII

Further experiments on the chestnut tree

After a few days, Alfanhuí went down into the cave
again and found the spider close to death, its light
very dim, because it had been tethered to the wall
and was unable to feed. Six different colours were
now flowing down the descending veins and into the
pool, where they traced rainbow circles in the water
which was now a darker shade of green. Alfanhuí
released the spider and let it plunge back into the
pool to revive itself by drinking from the veins. The
spider now fed on colours other than green, drank in
the mingled lights and was restored to life again.
Then Alfanhuí bunched the descending threads
together according to colour and placed five of these
bunches in their respective basins. Since orange was
the cheapest dye to make, he left the spider to feed on
that.

The cave continued to be brilliantly lit, for the
liquids were drawn up to the leaves only to return
laden with light, and none of the basins was ever
empty apart from the one containing the orange dye,
because that flowed directly into the pool and was
immediately absorbed by the spider. At night, the
liquids would grow dark again and they became very
sensitive to any changes in the quality of the light.
When the sky was overcast, the liquids would turn
cloudy and milky. At the end of the day, the basins

glowed brightly, illuminating the cave with the kind of coloured lights you might expect at a circus performance. The orange dye was renewed every now and then, and the spider gave off a smell of orange blossom that perfumed the whole cave.

In the months that followed, Alfanhuí and his master set about perfecting the chestnut tree experiment, and no sooner had they finished work on one stage than they would study the situation again and think up new ideas to put into practice. The master prepared more dyes, and soon the platform round the cave was filled with basins, and the leaves of the chestnut tree were painted more than thirty different colours of every hue and shade. They were careful too in the distribution of the colours, so that no leaf had the same colour on both sides of its seven segments. This was extremely difficult to achieve because it involved identifying the seven rising veins and the seven descending veins of each leaf, of which there were more than three thousand. The spider was fed on all of the different colours in turn and, with each one, it changed not only its colour, but also its shape. Its legs would sprout hairs or lengthen and thicken, its body would become oval or round like a cheese, or its skin wrinkled. In short, it took on the most varied of shapes, according to the nature and essence of each colour. In their book of experiments, Alfanhuí and his master noted down the spider's changing shapes and the colours that had provoked them.

They also managed to create water made from light. To achieve this, Alfanhuí would go down to the

cave, separate out a root, place the tip in a small bottle and then run his fingers up and down, squeezing the root as if he were milking; he would repeat the same process with four or five other roots until the bottle was full. Then he would take the bottle back up to his master, who would seal it in a vacuum so that the air would not eat away at the light. Thus they acquired a shelf full of more than thirty luminous bottles all containing different colours that glowed in the dark. On another occasion, they had the idea of grafting eyebuds onto the bark of the smaller branches. An eyebud is the duct from which tears spring and is all that is required to create a whole eye. When the season for chestnuts came round, several of the fruits, when opened, contained a coloured eye, even though from the outside the cases looked just the same as those containing ordinary chestnuts. Alfanhuí and his master would leave these eyes to soak in limewater for a long time so that they would fossilize and then be used on the animals they stuffed, for these eyes possessed a life and expression that glass eyes lacked. Those they did not fossilize would dry like fruit, but they never turned putrid or rotten.

Another idea was to graft white feathers onto the leaf stems. They had to use feathers that were not yet fully developed, that still had liquid in the quill because, if the quill was dry, the feather would not meld with the sap of the tree. In this way, Alfanhuí and his master created feathers of every conceivable colour to replace those that were damaged in their work as taxidermists. Alfanhuí even had the idea of

61

using the feathers to make an imaginary bird, piecing it together, like a mosaic, on a framework of cloth and wire.

At night, he would discuss all these things with his master, and they would spend long, fruitful hours by the fireside.

Alfanhuí and his master created various decorative birds in unusual colours, but their customers were scandalised and refused to buy them.

XIII

*In which we learn how Alfanhuí became a journeyman
taxidermist and about the marvellous experiment that
ensued*

One day, his master called Alfanhuí to bestow on him
the title of journeyman. That day, he told him his
last remaining secrets. In turn, Alfanhuí told him
how, when he was still living with his mother, he had
once collected the blood from the sunset. His master
shook him by the hand and presented him with a
lizard made of green bronze.

Some time later, they carried out a new experi-
ment. They extracted the vital force from the ovaries
of certain birds and grafted them onto the chestnut
tree. They did this with several different species of
bird and once more waited for the chestnut season to
come around.

When it did, Alfanhuí and his master awaited
the results with great excitement. They picked the
chestnuts and they started opening the cases one
by one because, since all the chestnuts looked the
same from the outside, there was no way of telling
which ones had been produced by the grafts. They
opened chestnut after chestnut and threw them
into a bag. At last, they came upon a grafted fruit.
Alfanhuí carefully opened the case and found inside
it a soft, green egg. The shell was made of some-
thing resembling a membrane or the skin of some

sea creature, and inside was what looked like a crumpled handkerchief. The master thought that if the creature was to live, the egg would have to incubate, and so they placed it on the millstone in the sun. They found more than twenty grafted chestnuts of different colours and did the same with all of them.

After a few days, the eggs began to move like men tied up in a sack. Alfanhuí and his master decided to open them. They slit the skin of the first one and inside was a coloured object, like a handful of flaccid, wrinkled leaves. They watched it beginning to unfold and open out like a handkerchief unfurling and, suddenly, there before them was a strange bird. All its body parts were flat like sheets of paper and it had leaves for feathers. Instead of two wings, it had five, unevenly distributed. It had three legs and two heads, both of them flat like the rest of its body. Alfanhuí and his master realised that the bird had been born with the symmetry of a plant and therefore had no set number or order for its different body parts, just as there is no set number or order for the branches of a tree. But they could see what kind of embryo it had been born from, because what shapes they could distinguish matched those of the purple heron, albeit a one-dimensional one, like a drawing on paper. It was brilliantly coloured and it kept chirruping softly, like someone whistling through his teeth. The master picked it up and threw it into the air. The bird opened its five wings and started flying, battling against the wind, like a brightly coloured rag,

swaying like a dry leaf with no fixed direction, coming and going in the air like a butterfly. Alfanhuí and his master were so thrilled that they immediately opened the other eggs.

The sky above the garden became filled with these colourful birds, some bigger, some smaller, who were all making their first flight and so never strayed far from the tree. It was as if the carnival costumes of a festival of birds had been tossed into the air or as if someone had scattered some brightly coloured leaflets from a balcony.

They formed a marvellous, weightless flock flitting across the sky in harmonious disorder. A bright, mad, disorderly, cheerful flock such as had never been seen before.

Alfanhuí and his master could identify the original species that each of these botanical birds had sprung from and they would stand enraptured, looking up at the bizarre birds flying about the garden and listening to the quiet, disparate calls they made: the sound of leather on leather or of knives being sharpened.

After a while, the birds would all alight on the chestnut tree because they had been born there and that was their home. Later still, the botanical birds took to flying about the countryside, but every night, they would come back to roost amongst the leaves of the tree. Alfanhuí and his master were thrilled with their multicoloured, multiform flock of birds, and they would carefully count them every evening when the birds returned to sleep in the chestnut tree. Then, one bird failed to return, and they felt very sad because they had grown fond of them all.

The bird had been killed by a hunter, and, in Guadalajara, monstrous, scandalous tales were already rife.

XIV

Concerning the sad events that occurred one night

At midnight, Alfanhuí and his master were woken by
the murmur of an angry rabble coming up the street.
The hubbub grew gradually louder, like an approach-
ing storm. Alfanhuí peered through the spyhole in
the door and saw, in the night, a group of men
carrying sticks, rifles and torches, all shouting:

'Drive out the devil, drive out the devil!'

And they were saying all kinds of other bad things
too. The men reached the door and began pounding
on it, their voices and their insults growing louder.

Still in his nightshirt and carrying the oil lamp,
the master went down to the hall, opened the door
and asked mildly:

'May I help you?'

The men did not reply, their voices and insults only
increased in volume, and they knocked him down
and trampled him, kicking him as they went. Then
they swarmed all over the house, smashing every-
thing with their sticks or with the butts of their
rifles. Alfanhuí stood by the wall, watching it all
sadly, and the men passed by and took no notice of
him. When they had destroyed everything, they
went out into the street again and seemed to move
off.

Alfanhuí went over to his master, who was lying on
the floor, bruised and bleeding. He brought him some

water and staunched his wounds with cloths. His master revived a little. A few moments later, however, they realised that the whole house was on fire. Torches had been thrown into the house, and smoke and flickering flames were soon pouring in through every door, the flames licking over the furniture and the wooden floor.

Alfanhuí and his master prepared themselves to flee. They dressed hurriedly, but saw that it was now impossible to get out through the front door. Alfanhuí picked up the gold coin the thieves had given him, and which he had hidden next to the silver snake and the lizard his master had presented him with. Then he smashed the glass case and released the snake of the three rings, saying:

'Quick, escape!'

The snake woke from its sleep, leapt over the flames, and coiled itself around Alfanhuí's wrist, like a bracelet. Alfanhuí grabbed the bronze lizard and ran back to his master, who took him by the hand and led him to the rear window of the house, which opened onto the fields.

They left by that window and started running across country; in the darkness, they forded a stream and climbed a hill. The blaze lit them from behind and glowed red on their backs. Before going over the hill, they stopped and turned to look at the house as if for the last time. Immense flames of every colour were shooting up; they could be seen glowing in the distance. The flames had caught the chestnut tree too, and they could hear their birds being burned alive, crackling and spitting like green twigs. Inside

the house could be heard explosions and the shattering of pots and glass objects. The hayloft caught fire and the straw went up in a vast red and yellow flame amidst the screams of mice being roasted alive. Alfanhuí suddenly remembered the two thieves and looked around him. He saw two shadows fleeing the fire, up another higher, barer hill, to the bleak Molina plateau.

Alfanhuí and his master watched the fire for a long time, not saying a word. Suddenly, the house fell in with a terrific crash, sending up a black column of soot and splinters that obscured the flames. The flames died down and the noise dwindled, and what remained was a field of scattered bonfires, a field of rubble that had once been a house.

After one last glance, Alfanhuí and his master turned their backs on the fire, walked over the hill and plunged into the dark night.

XV

In which we learn about the death of the master in the country around Guadalajara

In the country around Guadalajara, the blackthorn blossom is becoming tinged with yellow. It competes with the scarlet flowers on the clumps of thyme. A mist of tender green spreads over the black earth and the rough bushes. In the country around Guadalajara, a few small, dark larks rise with the dawn; they have speckled breasts and fragile beaks. The paths cross the high limestone mesetas that slope down into the steep valleys. Once a year, in the distance, you might glimpse the tricorn hats of the civil guard who are out riding along these paths. But the paths belong to foxes and thieves, and the civil guard are in the city, at the social club, playing dominos with a local grocer, his thumbs hooked in his waistcoat. Thieves sleep in the underground passages of the castles that crown the steep hills, and little old ladies dressed in black, sisters of the cooking pot and the frying pan, dance in a ring in the green fields. The little old ladies have bones made of wire and they outlive the men and the poplars. They drown in the fords which cross the Henares river, and the current carries them off like black rags. Sometimes they get tangled up in the willows or in the spurge bushes that grow by the cutwaters of bridges, or they get caught on fishermen's hooks.

The little old ladies of Guadalajara always go around together and, when one of their number drowns, they run away and say not a word to anyone.

The men who go fishing in Guadalajara always go down to the river alone and eat their lunch under the elms. The Henares is a muddy river that flows through dark lands and comes from the dark mountains. It is composed of the remnants of clouds left behind on the topmost peaks of the mountain range. The mountains are only ever partially covered with snow because the earth is so black, and the snow never quite settles. So dark is the shadow cast by the mountain, it seems as if the light of the sun never touches the land.

Alfanhuí and his master walked for three days. The wheat was still green in the fields, and his master seemed to be stooping closer and closer to the clods of earth. He lay down beside a hare's bed. He stretched out comfortably on his back, his head resting on a pillow of wheat.

'I'm dying, Alfanhuí!'

The master was talking very slowly. Alfanhuí's lips and eyelids quivered. He could feel rain falling inside his head and he knelt down beside his master. He could not speak.

'I'm dying, Alfanhuí!'

Alfanhuí felt his eyes filling with tears, felt the thread of grief mounting in his throat.

'I'm dying, Alfanhuí!'

For the first time in his life, Alfanhuí broke into sobs, as if something inside him had burst:

'Don't die, master, don't die! Please don't die, dear master! Get up, get up!'

And he tried to pull him up by the arms, but he couldn't lift him, because his master had lost all strength.

'Get up, get up!'

When he saw that he could not drag him to his feet, his voice died away again and he covered his face with his hands and wept.

'Alfanhuí, my child, I am going to the white kingdom.'

The master fell silent again, and all that could be heard were Alfanhuí's desolate sobs.

'I am going to the white kingdom where the colours of all things can be found, Alfanhuí.'

'Don't go, master.'

'I've left you all I had; if you ever go back there, the land and the little that's left are yours.'

'Master, dear master, won't you at least try to get up, or sit perhaps. Don't leave me all alone. I've never seen anyone die.'

'Be a good lad, Alfanhuí; go back to your mother.'

'No, it's you I love, master, and I want you to live.'

'I'm dying, Alfanhuí. I will say no more. I am going to the kingdom where all colours become one.'

This time, his master grew very still, and his eyes gradually dimmed. Alfanhuí put his head on his master's chest and wept. A long time passed, and then Alfanhuí felt on his neck the caress of a stiff hand slowly closing. The fist closed firmly about a lock of Alfanhuí's hair. His master stopped breathing, and Alfanhuí did not cry any more. He looked up, dazed,

and when he released the lock of hair from his master's grasp, a few hairs remained trapped between the dead man's gnarled, livid fingers.

Alfanhuí covered his master with a little earth and pulled up some wheat and lay that over his body too. Then, still dazed, he started walking across the fields. He had only gone ten paces when a hare started up, and he watched it disappear into the distance. Alfanhuí wandered aimlessly all day. As night fell, he reached an oak wood and he lay down to sleep beneath the dead leaves.

A beautiful moon rose and shone down through the branches of the oak trees. The silver snake slowly uncoiled itself from Alfanhuí's wrist and stretched out in the moonlight. Alfanhuí had his bronze lizard in one pocket and his gold coin in the other. He slept covered by the dead leaves and with the moon shining on his forehead, safe from the cold night in the country around Guadalajara.

XVI

How Alfanhuí went back to his mother's house, where he found her picking over lentils

The early morning train! The ground in the oak wood trembled. The black engine came snorting past, pushing ahead of it the dead leaves that had piled up on the line. The cool dawn breeze chattered in the windows. The train passed by only five yards from where Alfanhuí was lying, and the one hundred impassive, unknown faces in those windows pierced his sleepy eyes. The last carriage left behind it a whirl of dust and dry leaves. That abrupt awakening to a long, rapid drumroll had left the air trembling and empty. The silence sliced in two by the noisy passing of the train; the solitude of the lion-coloured oak wood pierced by one hundred dreaming faces.

Alfanhuí touched his body and it felt warm as if newly emerged from a bath of clean, bright tears. He looked for the snake, the gold coin and the bronze lizard and then he remembered everything. The snake was once more coiled about his wrist.

Alfanhuí set off south along the railway line. And by nightfall, he reached a broad moonlit plain. The plain was a dark mirror, white and green. Skeins of mist traced circles on the ground.

On the third night, Alfanhuí reached his mother's house. The house was sleeping, breathing softly, amongst the dark eucalyptus trees next to the

75

millrace. Cobwebs and woodworm fidgeted in the eaves, and the acrobatic spirit of the embers danced on the edge of the chimney pot.

Alfanhuí slipped in through the window and lit a lamp. He found his hour glass on the bedside table in his room. The fine blue sand was sleeping in the lower half like the sand in a dried-up river bed. Alfanhuí turned the hour glass over, and the sand reawoke and began to flow once more. Alfanhuí watched the fine blue sand falling, and the faint light of times past returned to his eyes. Then he got into bed and turned down the lamp.

Shortly afterwards, he heard noises coming from another room. He got up and saw a light on in the doorway at the bottom of the corridor. He looked in and saw his mother picking over some lentils. Since she did not notice him, Alfanhuí stood for a moment watching from the door. Then he went over to the table.

'When did you get back?'

'Hello, mother!'

Alfanhuí sat down next to his mother and started playing with the seeds, stones and bits of twig that his mother removed from the lentils. He was leaning on the marble table top with his head resting on his hand. As he told his story, he made patterns with the seeds, only to unmake them. Then he wrote his name in seeds and said:

'Mother, call me Alfanhuí.'

Alfanhuí had been away from his mother's house for a long time. He recognised the creaking of the beams in the kitchen, the ants' nests amongst the

flagstones, the imperfections in the marble, the grain in the wood, the dripping brass tap, the dents in the pots and pans, and all the other small secrets of the kitchen. On one shelf he could see the spice jars and their labels:

PAPRIKA, SAFFRON, BLACK PEPPER, ANISEED,
CUMIN, CINNAMON, NUTMEG, ETC.

Alfanhuí remembered the monotonous smell of his mother's stews. He saw the earthenware milk jug with its layer of thick, yellowish cream. And the pine chairs that had been scrubbed almost white. The cats, their eyes half-open, were dozing and purring on the warm flagstones by the fire. An earwig skittered over the frying pans hanging on the walls of the chimney hood. And altogether the noises of the kitchen composed a sound like gnawing woodworm that rose up through the coffered ceiling to the dark roof beyond.

Alfanhuí went back to bed, feeling as sad as if he had a nest of crows in his breast. He lay thinking, his hands behind his head, and he could see no new shapes in the darkness and found the shadows dull and blank, as if he had been blindfolded with a black bandage.

He imagined only that he could hear the imperceptible falling of the fine, blue sand of times past in the hour glass. And he perceived that solitary blue as the fine sand of a long, empty beach, of a tiny, monochrome beach with but a single path through blue grasshoppers, blue wheat and blue conch shells.

XVII

*How the summer passed and how Alfanhuí went down
to the fields with the men at harvest time*

When harvest time came, Alfanhuí set off with the
men to the fields. He rode on a donkey behind the
troop of harvesters. They followed the path past the
orchards, where the branches of the fruit trees
reached out over the walls. Alfanhuí always came
last, silent and thoughtful, amongst the pile of
saddlebags, with the sickles and the food.

Alfanhuí tied up sheaves or put away the harvest-
ers' bundles. One day, they told him to prepare the
gazpacho soup because the man who usually made it
had failed to turn up. Alfanhuí chopped up each
ingredient one by one in the earthenware kneading
trough: tomatoes, bread, melon, red peppers, green
peppers, cucumbers, onions, etc. and he mixed it all
together with the water and the oil. Then he half-
closed his eyes so that he could judge by the colour
how it was coming on, and then he would add a little
more of this or a little more of that, depending on
what he felt was needed. When the men came for
their lunch, Alfanhuí had the gazpacho prepared and
ready. He had made it with such skill, and everyone
enjoyed it so much that, from then on, it became his
task to make it every day. Alfanhuí responded to the
men's words of praise with a faint, timid smile that
barely concealed his sadness.

Everyone said to him: 'do this' or 'do that', 'take this' or 'fetch that' and Alfanhuí always obeyed. But no one dared say any more than that to him or to ask him questions apart from things to do with the harvest. His mother had sent him off with the men so as not to see him languishing at home, and Alfanhuí always did as he was told. At night, he would return to the house, have supper and fall asleep, absorbed in thought as usual, but his eyes were as dull as if he had seen nothing. Thus the time of harvest passed and the time of threshing.

The only time that his eyes ever shone with joy was when he was allowed on the threshing machine and had to crack the whip to get the horses moving. Sometimes, he would drive them so hard that the thresher would leave the threshing floor altogether, and the stones and the metal claws would scrape along the ground and come to a halt; then he would turn immediately, shouting wildly at the horses in his high, shrill, child's voice. He seemed so happy on the threshing machine that the men, seeing him there so upright and alive, often let him ride it for as long as he liked, urging the beasts on and cracking his whip in the air, as if the summer were not long enough for him and as if he wanted to run faster than the day and faster than the wind, mounted on that golden wheel, as if on a carousel.

September came around and the wheat was stored away in the silos and the granaries. The watermill near Alfanhuí's house began to work, and the sound of running water filled the days. Alfanhuí used to sit on a little bridge over the stream, with his feet

dangling over the water, and he would spend hours and hours watching the flow of the current and observing the comings and goings of the pond-skaters that skimmed across the surface, poised on slender legs, as well as beetles, black as shining enamel, that moved about in the water, leaving zigzag trails behind them.

But Alfanhuí had drawn a veil over his eyes and had dulled the sharp edge of his gaze and he saw all these things as a fool might see them, as if he would never again have another ingenious idea.

Sometimes, a eucalyptus leaf would fall into the water and would drift along, curled up like a boat, towards the wheel of the watermill. Sometimes dragonflies of every conceivable hue would hover above the surface of the water near Alfanhuí's feet. On the bottom of the stream, Alfanhuí could see algae and white and green stones. Sometimes the pebbles would roll, pushed along by the current. And the algae, combed by the waters, would wave like long hair in the wind. Everything called to Alfanhuí as if to tempt and awaken him, but Alfanhuí remained absorbed and absent, far removed from all ingenious thoughts, thinking only of his master, his house and Guadalajara.

81

XVIII

How the snow rid Alfanhuí of his melancholy

When winter came, Alfanhuí moved closer to the fire; he would sit on a stool to the left of the stove, in the chimney corner. He would stare into the fire and say nothing. The face of the fire would look back at him. The fire had eyes and a mouth. Its mouth, full of splinter teeth, crackled and talked. Above the eyes of the fire was his master's forehead. The fire spoke with its ancient teeth; it made ears of wheat and then shucked off the grain. Every ear of wheat was a story, every story a smile. The stories rose up from the fire like handfuls of wheat grain scattered on the stone hearth. The echo of stories sleeps inside the chimneys. The wind tries to erase them. The fire awakens them. The fire woke his master's forehead from the depths of Alfanhuí's gaze. A high, clear forehead. Alfanhuí listened to the repeated stories; he picked up the scattered grain, he recognised the voice. He recognised too, amongst the grain, his old smiles. Whole nights went by. The stories gusted in on the flames, filling the kitchen. Now the fire was rising and falling alone, alone it grew higher and alone it died down. Alfanhuí was looking and listening. Then he stopped looking and no longer listened.

It was a cold night and everyone was in bed. Alfanhuí was by the fire; the air in the kitchen was

83

hot, sticky and soft like a viscous oil eager to slip out through the cracks. The suffocating atmosphere in the kitchen forced the objects in it into a stubborn, turbid sleep. And everything tossed and turned in the hot, airless room. The spiders, the cats, the woodworm and the ants began shifting anxiously about, scratching, pacing up and down, trying to get a breath of the chill air coming in through the cracks. The cats walked up and down, climbed on the chairs, the table and the window sills; they walked around the room, keeping close to the walls, miaowing softly, restlessly. The room was lit by a large lamp; Alfanhuí looked around the room. Everything was grey, even the cats and the fire were grey, a dense, oily, ashen grey. The only glow came from the icy air pushing its way in through the cracks, as if trying to cut through that thick, blind morass. But the air had only to come into contact with the heat to lose its impetus, dissolving, bending and softening like wax. Alfanhuí got up from the fire and put his ear to a crack. It was a thin crack in the frame of one of the windows. He felt the sweet, silent air, soft, constant and slippery as the touch of a cold sheet.

Alfanhuí opened the door of the house. The light from the kitchen went out into the fields, and the kitchen drew in the night like a mouth taking a long in-breath, filling its lungs. It could be heard breathing deeply, drinking its fill of the cool. Alfanhuí was standing in the doorway. Outside lay the snow.

A passing hare was drawn to the glow from the kitchen and it sat on its haunches by the door, looking at Alfanhuí. Alfanhuí felt something urging

84

his muscles on and he began to run. The hare bounded ahead, capering silently over the snow. They ran towards a treeless hill, entirely white. The clouds had vanished, and the moon appeared. Alfanhuí ran on, gulping down the air. Below him, he could see the kitchen door like an explosion of light in the fields. Alfanhuí headed for a small wood of bare poplars that were juggling the moon in their wand-like branches. On the other side of the wood was a steep downward slope. Alfanhuí and the hare began to play together amongst the closely planted trees, weaving in and out of the poplars and crisscrossing their footprints over the snowy ground. Then they ran still further, past the stream, as far as the mill, and from there to another hill, and from the hill to another copse, circling the house down below. They were at the rear of the house now and, though they could not see the light from the kitchen, the moon was very bright. And so they ran and ran until Alfanhuí could breathe no more and filled his lungs with the snowy air.

Alfanhuí gathered an armful of new, damp, green firewood and went back down to the house. He used the embers in the fire to light the wood, which crackled and snorted, spitting out water and smoke as if refusing to burn, but finally doing so with a cold, metallic flame that illuminated the whole kitchen with a clear, young, lively light. The cats, the spiders, the woodworm and the ants all fled.

Standing by the fire, Alfanhuí looked out through the wide-open door and saw that day was beginning to dawn over the snow-covered fields.

PART TWO

I

*In which the reader is introduced to the
character of Don Zana*

Madrid. This was in the days of Don Zana the Mar-
ionette, he of the hair made from cream-coloured
shoelaces, he of the broad, watermelon smile, he of
the tap dance

> *Traque, traque, traque*
> *Traque, traque tra*

on table tops and on coffins. This was in the days
when there were geraniums on every balcony, stalls in
Moncloa selling sunflower seeds to eat and woolly
sheep grazing the empty plots in Guindalera. Drag-
ging their fleeces with them, they would eat the grass
growing amongst the rubble, bleating at anyone who
passed. Sometimes they would get into people's
courtyards and eat the green sprigs of parsley in
summer, in the well-watered shade of the courtyards,
by cool basement windows. Or they would trample
the sheets hung out to dry, the vests and pink long
johns pinned to the ground like the bright shadow of
a pretty girl. This, then, was in the days of Don Zana
the Marionette.

Don Zana was a handsome, smiling man, thin,
but with broad, angular shoulders. His torso formed
a trapezium. He wore a white shirt, a green flannel

89

jacket, a bow tie, light trousers and plum-coloured shoes on small, nimble feet. This was Don Zana the Marionette, he who danced on table tops and coffins. He awoke one day, hanging up in the dusty theatre store cupboard, alongside an eighteenth-century lady with a lot of white ringlets and an intricately carved face. Although the lady had danced with him in the theatres of Paris, she, having less temperament, did not wake up. Don Zana escaped onto the roof through a tiny window and spent some days jigging about on the tiles, frightening the people who lived in the attic rooms and garrets.

Don Zana smashed flower pots with his hand and laughed at everything. He had an unpleasant voice, like the crunch of dry canes breaking; he talked nineteen to the dozen and sat on the stools in taverns getting drunk. He would throw his cards in the air whenever he lost and never bother to bend down and pick them up. Many felt the force of his wooden hand on their face, many listened to his horrible songs, and everyone saw him dancing on table tops. He liked to argue and to go visiting. He danced in lifts and on landings, overturned inkwells and pounded pianos with his small, stiff, gloved hands.

The daughter of a fruiterer fell in love with him and gave him apricots and cherries. Don Zana kept the stones to make her think he loved her. The young girl wept when days passed without Don Zana even visiting her street. Then, one day, he took her out for a walk. With her as yet bloodless, quince lips, the fruiterer's daughter innocently kissed that

watermelon smile. She went home in tears and, without a word to anyone, died of grief.

Don Zana used to wander the outskirts of Madrid and catch small, grubby fish in the Manzanares river. Then he would fry them over a fire made from dry leaves. He slept in a boarding house where he was the only guest. Every morning he would sit and have them polish his plum-coloured shoes. He would breakfast on a large cup of hot chocolate and would not return until late at night or in the early hours of the morning.

Don Zana worked in a chocolate factory, and no one had better hands for beating the paste. His hands were wooden carpet beaters, with stiff, outstretched fingers all stuck together and only sketchily drawn. He worked with remarkable speed; he would take the paste and beat it and toss it like no one else. He performed like a juggler, as if he were at the circus, and gave a rhythm to his beating that seemed to set the pace for all the other workers in the factory. The manager had never had a worker as good as Don Zana, and Don Zana's chocolate was in a class of its own. So much so that they launched a bitter chocolate sold in a block, which they called 'Donzana', a chocolate so thick and dark you had to pull it apart like liquorice, forming what geologists call a conchoidal fracture, and which won a gold medal at the World Fair in Barcelona. With it, La Sabrosa plc reached heights that its humble managing director could never have imagined; he expanded his factories, and his income increased a hundredfold. It was at this peak of success that Don Zana chose to leave, on

the pretext that his hands were beginning to splinter with so much beating of chocolate. The pleas of the managing director and the board of directors, of which he was also a member, were to no avail. Don Zana climbed onto the table and scandalised the other directors by performing his dance:

Traque, traque, traque,
Traque, traque, tra

then he simply cleared off and no one could stop him.

For a few months after that, the company managed to maintain its prestige, producing counterfeit bars of Donzana chocolate; but the public was not to be fooled, and soon La Sabrosa plc went bankrupt, closed its factories and went into liquidation.

Don Zana roamed the streets, going wherever his plum-coloured shoes chose to take him, and with no one to stop him. Don Zana the Marionette did many other disreputable things and gained a sad notoriety in Madrid in the days when there were geraniums on every balcony, stalls in Moncloa selling sunflower seeds to eat and flocks of woolly sheep grazing the empty plots in Guindalera.

II

*Concerning Alfanhuí's arrival in the city and his
visions of the same*

Alfanhuí was wearing a yellow shirt and a black suit
with short trousers. When, with only half an hour of
daylight left, a woman said to him: 'You can see
Madrid from the corner of that wall', he took off his
espadrilles and put on the white socks and the pair of
patent leather shoes he was carrying in his bag. The
wall was very high; you could just see the cypress
trees over the top. At the corner, he stopped and
looked: he saw a road flanked by small trees leading
down to the river. On the other side of the river was
the city.

The city was purple. It faded into a backdrop of
grey smoke. Stretched out on the ground beneath a
low sky, it was a vast pelt bristling with cube-shaped
scales, with square, red sequins made of glass that
trembled as they mirrored the setting sun, like slen-
der sheets of beaten copper. It lay there, breathing.
Covering the city with its stone slab the colour of a
bruise was a flat, dark sky, like the underside of a
plain. The city was purple, but it could also be seen
as pink.

The city was pink and it was smiling sweetly. All
the houses had their eyes turned to the twilight.
Their faces were unadorned by paint or decoration.
The eaves fluttered their eyelashes. They were resting

their chins on each other's shoulders, piled up as if on a shelf. Some closed their eyes in order to sleep and stood there with the light on their face and a faint smile on their lips. The sun set. The birds were carrying in their beaks a vast, undulating grey veil, which came to rest over the city.

Once the sun had set, the air was like distilled alcohol. The silhouettes of things were sharp as broken glass. The smoke or veil was like a smudge on the lens, which altered the colours without blurring the outlines. The distilled alcohol had left everything exposed, clean and transparent. In that clear air, Alfanhuí saw four watercolour façades. Chartreuse, orange, aquamarine and pink. The crumbling outline of four tall adjoining façades, with no rooms and no eaves, and with windows staring wildly in all directions. The doors were new and it seemed that some-one had taken the trouble to close them. The four façades shared one long staircase, which, like every-thing else, was strangely clean. They were built at the foot of a hill, and a new road, as yet unused, ran past them. Facing an avenue and parallel to the river, the four façades looked both joyful and solitary. The avenue – really little more than a dirt road – was on a lower level and was lined by plane trees and acacias. A low wall looked out over the canalised river. It was a small river full of tiny islands, alluvial mounds of black sand, scattered with a little grass and rubbish and grubby, dishevelled cats with bloated bellies, washed up in the shallows. These islands formed a kind of fine-tooth comb made of thin twigs that stood in the current and collected in its teeth all

kinds of sad detritus. A small rusty iron bridge crossed the river at that point. Parts of the balustrade were missing, and the iron bars bent towards the river like branches. On the other side there were more plane trees and acacias. Beyond you could see a few vegetable gardens, building sites and embankments. There was no order there; everything had been started but nothing finished. As you looked up towards the city itself, streets began to appear. Alfanhuí was, as yet, still alone. On a hut in a vegetable garden he saw a sign:

BOULEVARD OF THE MELANCHOLY

The so-called boulevard was a rough track made of dull purple railway ballast and disappearing into the tangle of embankments. At the far end, you could see a dump car on its narrow rails. Growing alongside the track and separating it from the vegetable garden were brambles and wild olives. The vegetable garden itself was about four feet below the level of the track and contained neat rows of cabbages and lettuces, green as emeralds, growing in muddy water. Halfway along the track were five large old poplars, in whose broken branches many birds were roosting. Beside a ruined building was a roadside inn:

EL CORTIJO
WIDOW BUENAMENTE
Wines and snacks

It said on the wall. The 'R' of 'Cortijo' was painted

on the drainpipe so as not to break continuity. The
inn had a courtyard. Alfanhuí stood on tiptoe and
peered over the fence. There were a few small trees
and the dusty ground was raked smooth and damped
down with water from a bucket. There were a few
folding tables and chairs, painted a faded green. The
planks on the table were warped, and the nails were
sticking out. In one corner of the yard, a few wires
were strung up to support a honeysuckle arbour. It
was growing dark. Alfanhuí got down from the fence
and stood listening. He could hear a song coming
from the inn.

III

*How, when night had fallen, Don Zana and Alfanhuí
finally met*

At night, Madrid was filled by a multitude of red
lights that rose like steam up to the navy blue sky.
But in the depths of the Manzanares, the red and the
blue mingled. Beneath the black water, on the river
bottom, Alfanhuí could see an amethyst with a thou-
sand facets. Reflected in his patent leather shoes,
Madrid also looked like an amethyst. On the nearest
facet of the amethyst, he could see the avenue. The
trees were upside down and their leaves were tinged
purple by the glimmer of a lightbulb high up on a
bare post.

In Madrid, everyone wore patent leather shoes.
There were also many cockroaches on the wooden
floors. The Manzanares was the same; it ran like a
cockroach with an amethyst on its back, glowing
inwardly. If you were to step on its little islands of
mud and sticks they would make the sound of cock-
roaches trodden underfoot. The girls in Madrid did
not like cockroaches. All the newspapers were full of
advertisements for insecticides. It bordered on obses-
sion. Next to the advertisements for insecticides were
advertisements for shoe polish. Nothing else. The
patent leather shoes gleamed, but the cockroaches
survived. They invaded the kitchens; there was one
beneath every pan. When the fashion for patent

97

leather shoes was over, the fear of cockroaches vanished too. Everyone forgot all about it. And the newspapers advertised different products.

Alfanhuí saw a bonfire flare up in that same facet of the amethyst. In the light of the bonfire, the trees regained their true green. Alfanhuí looked up from the river and across at the avenue. Five boys were standing around a fire, their hands in their pockets. He went over to join them and, as was the custom in Guadalajara, he threw a stick onto the flames, in order to claim his share in the fire. Alfanhuí thought they would speak to him, but they merely made a space for him and continued to talk of strange things. Alfanhuí could not understand what they were saying. He understood the words, but not what they were talking about. They spoke very quickly, one after the other, without a pause. They used a lot of abbreviations, and all the words seemed to have two syllables. Finally, they showed him a ball bearing and Alfanhuí realised that this was what they had been talking about. He had never seen one before, and they explained what it was. He learned that ball bearings were better than roller bearings, except that the balls sometimes wore out. They were talking about making a cart. They also told him how to make one and how good it was going downhill in one of those low, wheeled carts that Alfanhuí had never seen. What he liked most was the fact that the ball bearings sometimes wore out and were then useless.

The bonfire burned down, and the boys went back to their homes. One was carrying a bunch of chard.

'Are you coming?'

They said.

'No, I'm staying here.'

Said Alfanhuí.

'Bye, then!'

'Bye!'

They had not asked his name and none of them wore short trousers like him.

A little light was seeping out through the cracks in the walls of the inn. A dog came trotting over the bridge. It was a skinny dog with mad eyes that gave a wide berth to anyone in its path. Then it slowed its pace and sniffed around near the lamppost. Alfanhuí walked across to the inn and went in. Everyone glanced over at the door. Don Zana was there too, sitting on a stool.

'Good evening.'

Widow Buenamente looked at him.

'Hello, sweetheart.'

There were four other men, three at the table with Don Zana and one at the bar, each with his glass of wine. Don Zana got up and went boldly over to Alfanhuí:

'What are you doing here, Paleface?'

When he looked at Alfanhuí, he cocked his head from side to side. Alfanhuí did not answer him.

'What's your name?'

'Alfanhuí.'

'Alfanhuí what?'

'Just Alfanhuí.'

'You look like a provincial. Have you got a trade?'

'Yes, I'm a journeyman taxidermist.'

Don Zana seemed worried. Alfanhuí was looking

at him like a bird. Don Zana was shorter than him.

'I had a trade once, but I got bored with it. Two, three, four trades in fact. An orthopedist in Espoz y Mina, chocolatier and dancer. It's far better to be an amateur dancer than a professional something else. That's what I do best. Life's a joke, dear boy. But you look a bit down in the mouth. Why so serious?'

A monkey tethered by a chain in one corner, greeted everything Don Zana said with shrill, forced guffaws, pretending to roll around on the floor with laughter, shuffling about and gesturing wildly. Then it would sit very still, waiting to hear what Don Zana said next in order to laugh at that too.

'But I like you, you're nice. What are you looking for?'

'A boarding house.'

'Come to mine. It's the absolute best, you'll see. I'll take you there. Give me your hand, Paleface, you and I are going to be friends.'

Don Zana held out his hand. Alfanhuí was surprised when he touched it.

'Where's your hand? That's not a hand.'

Don Zana again looked uneasy and anxious. The monkey gave a raucous titter and turned to the others in the room, showing the palms of his grotesque, dirty, wrinkled little hands. Everyone smirked inwardly, so that Don Zana wouldn't see, but he reacted by saying:

'Oh, it's a real hand all right. Look.'

And he went over to the monkey that had laughed in his face. The monkey cringed in abject terror, and

Don Zana unleashed a terrible blow. The monkey cried out and began to weep. Don Zana had hit it hard enough to make it bleed. Then he returned to the centre of the room and said to Alfanhuí:

'We'll go up to the boarding house in a moment. Would you like a glass of wine?'

'No.'

IV

*Concerning Señorita Flora and other matters of no
importance*

Alfanhuí opened the window of his room. It was a
clear morning on the balconies of Madrid. It was a
holiday. Alfanhuí looked up. His room was right
under the eaves. The ends of the beams, painted a
faded brown, stuck out like cracked wooden pegs.
Above, you could see the planks on which the tiles
were fixed, warped by the rain. With time, all the
knots in the wood had fallen away, leaving gaps that
served as hiding places for geckos. Alfanhuí remem-
bered the geckos in his own house and the little cry
they gave when they sallied forth at night to hunt for
flies, scurrying across the walls, so quick and strange.
They were prettier than lizards, he thought, despite
their dirty grey skin and their warts; with those wide
owlish eyes that can look in any direction, with that
broad, eccentric head, with those little hands with
tiny disks on the end, like sequins threaded on a
string. Lovers of the dark, they emerge at twilight,
looking sluggish, as if rubbing their eyes after sleep.
They soon bestir themselves, though, and then they
are the most agile of climbers, companions to the
spiders with whom they share the summer quota of
flies. The best hiding places are inside the plaster,
between the whitewash and the bricks in certain
badly constructed houses. No one knows that they

are, in fact, marvellously colourful, because when the dust of attics becomes stuck to their skin, they don the habits of hermit monks. But on the day of their death, if they rot in the sun, prodigious, iridescent greenish-yellows ooze from their little bellies, along with an odour of hay, figs and musk, like the odour of sanctity. When they are born, they are white and tremulous as squabs. Then, they undergo a similar metamorphosis to that of fawns or young wild boar and acquire dark spots on their skins, until, in later life, they put on the habits of their religious order and retire to live in caves. And there were so many geckos in his master's house and in his mother's house! Eternal companions of night-time chats when, at sunset, the dark arrives with a shudder.

Alfanhuí looked at the house opposite. On the roof was a dead teddy bear, its nose buried in the gutter, as if it had died of thirst during the last summer drought, searching for a drop of water on the red desert of the rooftops, wandering across its burning, impassive dunes. It had a wound in one side, leaking sawdust.

Alfanhuí looked down at the façade of the house opposite and noticed a painted window. But this one wasn't like other fake windows which at least look real once a day, when their shadow coincides with the one cast by the sun on the real windows. This window never looked real, because it had been painted with contradictory shadows. Its colours were green and brown, and the frame had been decorated exactly the same as its more fortunate companions, except that

the rain had made the colours run so that they trailed languidly down the wall.

A lady had been painted leaning on the sill of this window. This lady was still waiting for a husband. Her skin had grown flaccid and she was about forty-five years old. She may well have been waiting since she was fifteen. A pink and mauve lady who had not yet swathed her flesh and her beauty in black, but was still waiting, like a blown rose, with her faded rouge and her artificial smile, like a sour grimace. With the rain, her breasts had started slipping down the wall and now looked pendulous and lacklustre, about a hand's breadth from their proper place. She was gazing south through the gap between two tall houses, towards Pinto and its scorched fields, over the railway line to Toledo. Towards the yellow wheatfields and the white railway halts, under the joyful sun beneath which girls of eighteen get married. She was dreaming of the palaces of Aranjuez, of their gardens and groves, and of the River Tagus like an austere gentleman, and the royal irrigation system and the bright, rumbustious water leaping and booming against the lock gates. And the sturdy Valencians turning the great lock keys. And the neat, fertile meadows.

Waiting and waiting while the rain was slowly eroding her face and her blue woollen shawl. While time fell, sliding like a light shadow over her face, smoothing it away, merging it with the window, the wall, the wind. Ah, time, time, transforming her into a vague ghost, motionless on the wall, making her fade like a hopeless flower, while the women selling

vegetables in the street down below berated their troop of children and knocked some common sense into them, and sold the garlic, leeks, onions and carrots which would later fill the street with the vulgar smell of lunch, while the cyclists rode whistling down the narrow streets, scattering the people and the plump, pinchable maids with a shopping basket over one arm, and while everyone went shouting and bustling about their solid, vulgar lives, full of gossip and laughter.

If only that window had looked real! The shrewd widower from Toledo would have come, with his gold watch chain over his waistcoat, with his white shirt buttoned to the neck and his elegant hat. If only that window had not been painted with contradictory shadows!

The painted lady, mauve and pink, with her blue woollen shawl was still gazing out towards Pinto, to its scorched fields alongside the railway line to Toledo. She was still looking and waiting with her artificial smile. Her name was Flora. Señorita Flora. How very sad!

V

Concerning Doña Tere's curious boarding house and other matters

The boarding house was in a small apartment that opened onto a dark inner courtyard hung with food safes. And there were washing lines on every floor, strung from window to window. And when all the neighbours hung out their washing at the same time, the courtyard was layered with sheets, from ground to sky, like a piece of puff pastry. Then the light did reach down into the courtyard, because the topmost sheets received the sunlight that came sliding off the roof and passed the glow on down to the penultimate layer of sheets and these, in turn, to the next layer. And thus, in this complicated fashion, the light was passed gently, though not without difficulty, from sheet to sheet until, finally, it filled the entire courtyard, as far as the mezzanine floor. The light was utterly taken in by the sheets and, once it was poised at the top of that slippery slope and began the downward journey, it could not escape, it was caught in a trap, and was carried, much to its displeasure, to the very bottom of that dirty, cramped, grey courtyard. But the best part was when someone opened the patio door that gave onto the hallway, and in from the street came a blast of air that rushed into the courtyard like a whirlwind, catching up the sheets that would begin to flutter about high above,

like a frightened flock of geese, as if struggling to free themselves from the washing lines. On the few occasions when these cyclones occurred, the sheets never actually escaped. But – quite how no one knew – in the midst of all the confusion, the sheets all managed to change places, as if, when the wind stopped, each sheet plonked itself down in the first free place it found, the way schoolchildren do when the teacher suddenly walks into the classroom. Then the neighbours would have to find and identify their sheets and sort out the mess, which was the cause of a fair few quarrels, for not all the sheets were the same, some were good, some bad and some mediocre.

The house was triangular, would you believe, and the ground plan was in the form of a set square! And from the street, that high, sharp corner looked like a knife. The longest side of the triangle was the rear wall, made of brick and entirely windowless, which rose sheer into the air. The shorter sides did have windows, and the right angle coincided with the corner where two streets met. Inside there was a pine staircase with a wrought-iron balustrade and a wooden banister. When it reached the attic, the last stretch of balustrade was finished off with a glass ball. The front door of the boarding house was also an odd shape, because the landing sloped towards the stairwell. When this slope became more pronounced, the original door no longer fitted the twisted, dilapidated door frame. So when they made a new door, they made it in the form of a rhomboid so that it could shut properly. This was also not without its problems, because when you opened the door, the

bottom would scrape along the floor until it reached a point where it would go no further. In order that the door would lift as it was opened, they had to make a slight adjustment to the hinges and gouge out part of the landing floor. Eventually the door worked well, but only after they had planed away part of the support so that there was no friction when the door lifted. All this work was carried out by a carpenter from Calle de Atocha called Andrés García.

The door had a brass spyhole that resembled a slice of lemon. And when it was open, it resembled a Maltese cross because four of the segments were movable and four were not. You looked through the four movable segments. The spyhole also served as a vent for the heaters.

An enamel plaque on the door read:

TERESA'S BOARDING HOUSE
FOR RESIDENTIAL GUESTS

In the middle of the house was the main room, with a square table covered by a brown velvet cloth embossed with drawings of plants. Right in the middle of the table, as if they were the most important thing in the house, were the oil and vinegar bottles in the cruet stand. They were of the kind that resemble two retorts, joined at the base by two large glass drops. The one on the right pointed left and the one on the left pointed right. Don Zana always got confused and poured out oil when he wanted vinegar, and he was always angrier when he got vinegar instead of oil than when he got oil instead of vinegar.

He used to swear that they were the wrong way round, that he was used to the oil being on the right and the vinegar on the left, or viceversa, depending from which angle one looked at it. On some days Don Zana would say one thing and on other days another, and the landlady would usually respond with:

'Espadrilles don't have a left and a right, you know, they can be worn on either foot.'

In this room there was also a glass-fronted sideboard in which were kept the glasses and the crockery. Since it had one pane broken, however, no one ever opened the doors, they merely took everything out through the empty pane. There was also a low, bell-shaped lamp with a fringe of red threads and another fringe of slender glass tubes that were always dancing and swaying and which produced a kind of pastoral music because they sounded just like the tinkling bells on a flock of sheep. The shadows swung back and forth on the wall as if the whole room were rocking. On the sideboard was a tin bearing a reproduction of Velázquez's *The Topers*; it had once contained quince jelly, but was now used for buttons. It often gave strangers to the house a real fright because, shortly after closing the tin, there would be a sudden bang as the dent in the lid released itself and the lid returned to its original shape.

Other rooms worthy of mention were the bathroom and the maid's room. The latter was situated on the corner of the right angle. The maid was a tall, thin woman of about forty, who always wore curlers in her hair, except on Sundays when she went out. She had very thin hair and used to get up at

midnight, in her nightdress and carrying a candle-holder, in order to look at herself in the mirror. And since what she saw was unremittingly ugly, she would reach out and scratch the mirror. Then she would go back to bed and fall asleep with a beatific smile on her lips. Her name was Silvestra, and everyone called her Silve because, in Madrid, they never used words of more than two syllables.

The bathroom was a vegetable patch. The bath was filled almost to the top with soil, and in it grew three cabbages. The irrigation was very efficient, with furrows to distribute the water, and all one had to do was turn on the tap. The three cabbages were white because there was very little light in the room, and, as everyone knows, plants need sunlight in order to become green. But since they did not lack for water, the cabbages grew very fast, and every time one was picked, another was planted to replace it. It was the same winter or summer, autumn or spring. Also in the bathroom was a goat tethered to the door handle. This goat was always absolutely rigid, with its legs at full stretch and its body straining forwards, pulling on the rope as hard as it could, never once taking its eyes off the cabbages. Whenever anyone went into the bathroom, the door would fly open and the goat would be overjoyed to find itself a little nearer to the cabbages, wagging its tail like a puppy dog, in the fond belief that it was actually going to be allowed to eat them. When the door was open, the goat maintained pretty much the same posture as when the door was closed, only a little farther forward. Shutting the door was easy enough because

the floor was very slippery and, when you pulled the handle, the goat would simply slide back to its former position. The goat was called 'Fix' because it was almost as if it had been fixed in that position, and it produced some rather insipid milk.

VI

In which Doña Tere tells the story of her father, and we
learn more about Silve and Don Zana

Doña Tere was a small lady with a few grey hairs.
She was a delightful person and very considerate to
her guests. One night when Don Zana did not return
home, Alfanhuí sat up for a long time talking to her.
She was a widow; her husband had been a teacher.
The only book left in the house had belonged to her
husband. It was a book with an orange cover which
showed a girl blowing on a dandelion clock from
which some of the seedheads were breaking off and
flying away. The book was called *Petit Larousse
Illustré*. Alfanhuí got a great deal of pleasure from
looking at the pictures.

The landlady also told him the story of her father.
Her family was from Cuenca, which is where she had
met her husband. Her father had been a farm worker
with some land of his own. One afternoon, he fell
asleep while ploughing with the oxen. And since he
did not turn the plough, the oxen continued on out
of the field. The man went on walking, with his
hands on the plough handle. They were heading
west. They did not stop all night. They crossed fords
and mountains, and still the man did not wake up.
They followed the entire course of the River Tagus
and arrived in Portugal. And still the man did not
wake up. Some saw the man with his oxen ploughing

113

one long, straight furrow over mountains and across rivers, but no one dared to wake him. One morning, he reached the sea. He crossed the beach and the oxen waded into the water. The waves broke against their breasts. The man felt the water on his chest and woke up. He reined the oxen in and stopped ploughing. In a nearby village he asked where he was and sold the oxen and the plough. Then he took the money and returned home by following the furrow he had ploughed. That same day he made his will and died surrounded by his family.

Doña Tere had come to Madrid with her husband and they had rented an apartment. After he died, she opened it as a boarding house. Alfanhuí liked to hear these stories about people's lives. He would watch Doña Tere moving her lips and her eyes as she serenely put her memories into words, and during the time that she was speaking, Alfanhuí imagined the actual time occupied by the events she was recounting. Alfanhuí was very fond of Doña Tere, who gladly revealed to him her memories and her life, as if she were ushering him into another room in the house, saying cordially: 'Come in, make yourself at home.'

Then they talked about Don Zana. Doña Tere told him to be careful.

'He's not the right sort of friend for you.'

Every night, Doña Tere would serve them fried whiting in a spicy sauce, but her spicy sauce was much spicier than anyone else's. Silve used to sing a tango by Carlos Gardel while she fried the fish. It was always the same tango that began:

Farewell, lovely bird . . .

Silve was always in a good mood, but she did sometimes answer back. Doña Tere, however, never got angry; she merely found Silve's impudence funny and would placate her with laughter and kind words. Alfanhuí discovered that both the goat and the vegetable garden were Silve's idea. She had brought the goat with her from her village and would occasionally throw this fact in Doña Tere's face, as if the goat alone had saved the boarding house from ruin. For that is what she believed, and Doña Tere let her.

'Alfanhuí, Paleface!' Don Zana used to say. 'People are generally so stupid, so absurd. But I like you because you're the same as me.'

On some days they would go out walking together. Don Zana would show him Madrid. One day, they went to a station to watch a train leaving. An hour before the train was due to depart, men, women and children started arriving, carrying suitcases and wicker baskets. The women were usually wearing a headscarf and a harried look on their face, intent on boarding the train. They could think of nothing else and were exaggeratedly anxious. They would have everything prepared before they even reached the train.

'Now you get on first, then you hand him the suitcases through the window; you hold the baby and you grab the seats and you . . .'

But they ran out of children.

These women were like little ants. And the train gradually filled up, and the people saying goodbye

stood on the platform. Then everyone was kissing everyone else, and someone was crying. The train whistled, and the people on the platform waved their handkerchiefs until the train was out of sight.

On another day, Don Zana and Alfanhuí walked down a street on the outskirts of Madrid and came across a vast empty plot, slightly set back and piled high with rusty bits of metal; there were water tanks, car mudguards, boilers from trains, tubes, warped beams, cables, chairs, bedside tables and an endless number of other things, all of them like skeletons. In one corner there was a pile of dusty bottles, green as a *guardia civil*'s uniform. Next to them was the security guard's hut. The guard was an old man who sat on a chair at the entrance to his hut, puffing indifferently on a cigarette. Don Zana asked him:

'What exactly are you guarding, my good man?'

The guard opened his mouth to speak and then looked with sad, sad eyes at that black field of scrap iron and rusting debris.

They saw gypsies coming up the street, banging on their tambourines. A bear, camel, monkey and goat. The children ran after them. A moustachioed gypsy of about fifty made the bear dance by singing him a soft, simple, monotonous song. There were no words to the song, or else they had been forgotten. All the gypsy said was: 'Ohoooh, ohoooh, ooohoo-oh.' It was a Tartar song or perhaps Magyar, as was the man's voice and moustache. Then the gypsy said to the bear:

'Play drunk, Nicolás!'

And the bear rolled about on the ground. The

children laughed. The gypsy yanked the bear to his feet with the chain and led him away. Then it was the turn of the monkey, the camel and the goat; and grubby, dishevelled girls with carnations in their hair danced too. Some people threw coins into the cap they passed round, others threw money down from the balconies, but almost no one stopped, because they had seen it all a thousand times before, and it was a sad, dull spectacle. A gypsy girl went over to Don Zana and Alfanhuí, holding out her tambourine, but Don Zana said:

'Art, my dear, is beyond price.'

VII

Concerning a remarkable discovery: the abandoned house

The abandoned house was in an old, neglected quarter of the city, in a street of cobbles worn smooth by the passing of carts. The first thing you saw before reaching the house was a short stretch of high, brown wall on the street itself, with a huge, battered portal that led into a courtyard. The courtyard was surrounded on three sides by tall, dark porches. Underneath the porches were old carts and their remains – wheels and axles and wheel rims – a carpenter's table surrounded by yellow shavings, an anvil and a small forge. The beams were covered in cobwebs. In the central clearing, there were signs of a fire having been lit. On top of a pile of rags, a little dog was suckling her puppies and patiently licking them.

At the end of the wall was a tenement house full of voices and coloured tiles. After that came the gate. It opened into a narrow passageway, about a yard and a half long, between the tenement house and the abandoned house. The latter had its back to the street and a door that opened onto a garden at the end of the passageway. There were few trees in the garden; instead there were a lot of flowers planted in large tins and old buckets, lined up along the wall. In the middle were a few hedges surrounded

by a brick border and some bushes with white flowers on them. Someone obviously still tended the garden, for, leaning against the wall was a rake and, beside it, a green watering can. In the middle of the garden was a very tall, spreading cedar tree and a disproportionately large circular arbour made out of marble with four stone benches around the edges.

The single-storey house was made of red brick and had large windows and green wooden shutters. The door was clothed in a vast tangle of branches that smothered the stairway and the glass canopy and climbed onto the roof where they formed a large ball. It was as if the house had covered its face with that thicket of honeysuckle, ivy and other creepers. Alfanhuí went over to have a closer look; the sturdy stems embraced the banister and the ironwork on the canopy, twining around and becoming one with it. They wound and curled about, clinging as tightly as they could to everything in their path. All the glass panes in the canopy had been shattered by the encroaching creepers, as they pushed their way through in order to coil about the iron supports. On the floor, among the dry leaves, were dusty fragments of green and blue glass. The front door was completely hidden behind the dark foliage.

Alfanhuí clambered up the strongest stems and got underneath the leaves. Then he saw that below him were only branches and more branches and a black void. The plants had eaten out the entire wall above the door as well as the eaves and part of the roof, as if they had taken a great bite out of the house. It occurred to Alfanhuí that he could get into the house

by climbing down the branches. The foliage was at its densest here, it wrapped about him and seemed unending. Alfanhuí plunged in, pushing aside branches and leaves with his hands and feet. Sometimes it seemed to him that the stems were closing about him as if to squeeze him and suffocate him in the tangle. At last, he felt empty air beneath his feet; the last tendrils of the creepers dangled like ropes inside the house. Alfanhúi lowered himself down on one and dropped to the floor. The noise echoed through the darkness. He heard a scurry of rats. He stood still for a moment. It was intensely dark, apart from a faint smudge of light on the floor. Alfanhuí went closer; it was the fireplace. In that light you could see the shadows of two birds perched up on the roof, on the edge of the chimney. Alfanhuí heard the sound of far-off whistling and saw their shifting shadows on the floor. He lit a match and saw a large room, like a living room, but without a stick of furniture in it. The doors were white with gold mouldings. The fireplace was made of marble. Everything was either white or dark. Lighting another match, he went into an even larger room in which there was another fireplace. There was a mirror above the fireplace and two bronze candlesticks. He lit all the candles. The frame of the mirror was also white with gold edging. He looked at himself. The reflection in the mirror was deep and yellow: 'Don't I look old!' he said and smiled. Then he moved as far away from the mirror as he could and looked at himself again from a distance. From there he waved to himself:

'You do look old, Alfanhuí!'

He said again, jokingly. He smiled broadly and then picked up one of the candlesticks to light his steps. As he made his way to the door, he stumbled over something in the middle of the room. It was the skeleton of an angora cat. You could see bare bones and clumps of white fur round about. As he passed, some of the fur, caught by the draught caused by his feet, wafted up and clung to his socks.

On the floor of the next room he found a broken turquoise vase with a faded rose by its side. On the mantelpiece was a book almost eaten away by worms. He opened it and on the title page was written:

Abbé Lazzaro Spallanzani
Expériences pour servir à l'histoire de la génération
des animaux et des plantes. Genève 1786

He turned to the first page. If Alfanhuí had known French, this is what he would have read on the first line: 'I call the frog of which I am about to speak the green frog . . .' and he would have kept the book. What Alfanhuí also did not know was that all the books written by that same Abbot Spallanzani had been bequeathed to him by his master and destroyed in the fire at the house in Guadalajara.

Alfanhuí went into another room. There he could hear a strange buzzing. Lit by a tiny crack of light coming in through the window was a clavichord. White with gold edging. The buzzing was coming from there. Alfanhuí approached and touched a key. The key slowly gave beneath his finger and, after a

pause, produced a long, sweet, muffled note. He opened the lid of the clavichord. The buzzing grew even louder. He peered inside. The clavichord was a beehive. It looked as if it were filled with gold. The honeycombs were built into the harp, along the strings. The bees were working; some alighted on Alfanhuí's hands, others flew out through the crack of light, while others flew in through the same crack. Underneath the harp was a huge deposit of honey that took up the whole body of the clavichord and was about three inches thick. The honey was oozing out through the gaps in the wood and hung down to the floor. It hung in threads, like the fringe of a shawl.

For a long time, Alfanhuí stood watching the work of the bees and the hidden gold he had discovered. Outside, evening was falling. At last, he closed the beehive and left, first returning the bronze candlestick to its place. He climbed back up the creepers and out into the garden. The evening light dazzled him; he was in a sort of trance.

In the middle of the garden was a little girl of about seven. She had various coloured tin moulds which she was filling with damp earth and then turning out. On the ground lay a story book. When the girl saw Alfanhuí emerge from the creepers, she got to her feet and looked him up and down, bemused. Then she very charmingly asked him:

'Are you Sir Zarambel?'

VIII

Concerning the firemen of Madrid

One day, Alfanhuí and Don Zana witnessed a fire. A woman on a balcony was crying out in the most heartrending fashion. Smoke was seeping out from the cracks in the walls. People gathered around the house. In the distance, they could hear the approaching sound of the firemen's bell. The firemen arrived in splendour at the bottom of the road, with their scarlet car and their golden bell and their golden helmets, clean and shining. The firemen brought with them all the gaiety of a fiesta.

In those days, many little boys in Madrid wanted to be firemen. It was a time of peace, and all heroic children shared the same dream. Because the fireman was the hero of heroes, entirely without enemies, the most beneficent of men. Behind their large moustaches, their uniforms befitting civilian heroes, and their helmets worthy of Greeks or Trojans, firemen were good and respectful, not to mention equable and courteous, plump and kindly. All honour to the firemen!

Seen from another point of view, they were also the great friends of fires. You should have seen the joy with which they arrived, their enthusiasm for their work, their jubilant red cars. They did far more damage than was necessary with their axes. Bored with their life of unending stillness, the alarm bell

125

intoxicated them, the flames inflamed them, and they arrived at the blaze in euphoric mood. They set in motion their mechanism of pure activity and pure speed. They conquered the fire by virtue of being faster and more energetic than the fire itself. And the fire, humbled, retreated to its caves. They knew the fire's secret, the only useful weapon against the flames. For they outdid the fire in the very area that the fire most excelled: in movement and sheer drama. They humbled the fire. All eyes were turned on them; no one even looked at the fire.

They did not run as fast as the average person, but they ran correctly and athletically: chest out, arms at chest height, head up, lifting their feet high off the ground with their knees out, and they never bumped into each other. That was why everyone said:

'Don't they run well!'

They never brought anyone out through the front door, although they could have; instead they brought them out through windows or over balconies, because in order to triumph what mattered was the sheer spectacle of the thing. One fireman, in his zeal, carried a young woman all the way from the first floor to the fifth, so as to be able to save her from there.

Every floor had its young woman. All the other residents left the house before the firemen arrived. But the young women always stayed behind just so they could be saved. It was the sacred offering that the town made to its heroes, for without a lady there can be no hero. When the house started burning down, every young woman knew her duty. While everyone else hurriedly made their escape with the

household goods, the young women would rise, slow and tragic, allowing time for the flames to grow; they would remove all trace of make-up from their face, let down their long hair, undress and put on a white nightgown. And then, and only then, would they emerge, solemn and magnificent, onto the balcony to scream and wave their arms about.

This is how it seemed to Alfanhuí that day, and it was the same whenever there was a fire. The same thing always happened because it was a time of order and respect and good manners.

IX

Concerning the day before Carnival and Carnival night itself and the bitter end to a secret quarrel that had been growing between Alfanhuí and Don Zana

Day dawned at last, an intense, insidious dawn, with a hard steel sky and a hawkish wind. In the distance, a few white clouds were scudding eastwards. It was a sky full of haste, a sky in conflict. The city crouched silently in the middle of the fields like a great, fearful hare. The black metal chimneys, empty of smoke, creaked in the wind. The city was defenceless beneath the sky; the birds had deserted the air and the smoke the rooftops. The city was silent and turned its back to the wind like a startled animal. And the north wind beat the streets, invading them as if spoiling for revenge. The clothes cracked and slapped where they were hung out in the courtyards, or at the backs of houses looking out over empty plots. And the sun fell contemptuously on the city, with the flat light of the plains. The city was naked and exposed; it lay among the fields, empty of the dreams that usually protected it. With its eyes open, it felt afraid of its solitude and looked about it as if to say: 'I'm nothing compared with these fields.'

It was a day for the pale and vulnerable to go up onto the terrace roofs, to stare hollow-eyed at the mountains and to feel strong, for once, with the wind in their faces.

But behind the dark panes, women's eyes looked fearfully out at the day and the wind, and they said with a shudder: 'This doesn't bode well for Carnival!'

Thus the whole day passed, with the wind never ceasing to blow and with hardly anyone going out into the street. And by sunset, all dreams had been swept away, and the city was laid bare. Alfanhuí and Don Zana had not met up that day. Alfanhuí had spent the time strolling about the streets, his hands in his jacket pockets and his head up, as if sniffing the air, intent and cold.

When night fell, Alfanhuí and Don Zana were at opposite ends of the city: Don Zana in the south, Alfanhuí in the north, from where the wind was blowing.

Suddenly the wind dropped and the clocks chimed. Don Zana began looking for people in fancy dress. He went into houses, chose the saddest person there and made them put on a mask and go down into the street to laugh and sing. No one refused. Thus he collected together a few dozen people in masks and fancy dress and went with them to the centre. Alfanhuí, alone and determined, was advancing from the opposite direction.

The noise of the crowd of revellers could be heard from far off as they played, sang and danced, stopping now and then to receive a new member. At their head went Don Zana, forcing them to laugh, allowing them no rest. Some wore the masks of pigs or gorillas, others masks of clowns or masks with enormous noses. Their voices were distorted by these cardboard masks and emerged sounding more like

grunts. Some were crying inside and the paint on the masks began to run and smudge. But Don Zana would give them no respite. Sometimes they bumped into walls or lamp posts, and they slouched along, dragging their feet, stumbling and tripping over their long, colourful capes. The dark, disorderly crowd were at the mercy of their own laughter, stripped of all self-will, weighed down by a heavy burden. And they sang and howled and groaned, as if in the grip of some mass epileptic fit. Don Zana, the light, nimble paladin, formed a sharp contrast to those large, clumsy, hunched bodies, laden with clothes.

At last, Don Zana stopped. The whole procession bunched up behind him, like a formless mass, buzzing and swaying slightly at the edges, emitting a dull, nasal murmur. Don Zana did not move, staring at the far end of the street. A thin, white face stood out in the darkness; half the face was lit by the moon, the other half lay in shadow.

Alfanhuí and Don Zana looked at each other for a moment. Then Alfanhuí started walking. The rabble of carnival-goers silently disbanded, and each one fled down a street and disappeared into the night, leaving mask and costume crumpled on the ground.

Alfanhuí and Don Zana walked towards each other. Don Zana would have liked to run away, but Alfanhuí's eyes held him fixed to the spot.

They met on a dark street corner. There was anger in Alfanhuí's yellow eyes. He grabbed Don Zana by his feet, lifted him into the air and began beating him against the stone wall. Don Zana's large round head came loose, and his painted smile shattered on the

131

paving stones. His body sounded and reacted just like wood. Alfanhuí beat him so furiously that all that remained of Don Zana were splinters. In the end, Alfanhuí was left holding only the plum-coloured shoes. He hurled them down on the pile of splintered wood, took a deep breath and leaned against the wall. A night watchman came running over, shouting:

'Hey, what's all the noise about?'

Alfanhuí said only:

'Oh, nothing, it was just me.'

The night watchman saw Don Zana's remains scattered on the ground.

'What's all this?'

'As you can see, bits of wood and rag.'

Said Alfanhuí, while he casually pushed them down the drainhole.

X

Concerning Alfanhuí's blindness and his agonising flight

Alfanhuí opened his eyes with a bitter, smarting, painful sensation and found that he was blind. At first, the blindness was red, cayenne red or plum red like Don Zana's shoes.

'I didn't think Don Zana had blood in him.'

He touched himself: a fever was rising up his body and burning in his temples. A fever was making his hands so acutely sensitive that the tips of his fingers throbbed. It felt to him as if they were becoming horribly sharp and long. And they hurt if he so much as touched something, anything – the walls, the pavements, the streetlamps. And, in his blindness, he saw everything through his fingertips. And what they showed him was fleeting and vague, according to the nightmarish caprice of the shadows. The streetlamps were sticks of hot sealing wax dripping fiery drops. The walls were striking surfaces for matches that tried to inflame the tips of his long fingers, swollen with fever. He raised them to his mouth to cool them, and they tasted of blood. He walked very slowly, so as to hurt his hands as little as possible, but he could find no way out of those streets, which swung around to block his path, with the pent-up roar of every cart that had ever driven down them, as if they themselves ran on wooden

rollers. And the eaves stooped down to bruise his temples and his brow. He tried to rest and so he placed his hands on the ground, only to feel the furry brush of rats against his fingers. If he held his hands high in the air, he felt the tiny bites of bats.

'I didn't think Don Zana had blood in him.'

The streets again clattered with the sound of carts and again fell silent. Periodically, insistently, he was visited by alternating flashes of red and grey. The red of the plum-coloured shoes, the grey of rat fur. His eyes swelled up and grew small as if they were breathing in and out, and tepid drops of sweat oozed from his face. His hands became entangled in the branches of the acacia trees and his slender phalanges seemed to fracture. The acacia trees were black thorny brambles that shifted about and clung to each other. Occasionally he would scrape his fingers against the panes of a window. Even the air hurt his fingers now, and it was as if the whole street were filled by grey rags, hung up side by side like curtains. His hands were now his senses and they had grown large and keenly sensitive. As keen as his eagerness to escape and to orient himself, to change direction, to run away from the place where he had killed Don Zana.

'I'll never see Doña Tere again.'

He stopped for a moment. Despite his blindness and all the pain, he was not confused and could think calmly:

'I will look for the river, and on the other side of the river will be the countryside. I will never see Doña Tere again. That is how it must be.'

And once more he reached out his hands in front of him in order to go on and the harder he tried to find his way, the more his hands hurt him.

'I could rest; I could resign myself to not escaping, and then my hands would go back to what they once were. But I must leave.'

And he set off once again and resolved to look for a way out and to put up with all the pain and disgust felt by his fingers. Now his fever had lessened, and he felt instead a damp warmth shudderingly reminiscent of caves or the slimy touch of worms.

But the city was interminable, and he never even came close to the river. He considered climbing up to the rooftops in order to be able to breathe. Climbing was not difficult with his long, sharp hands and soon he was there. Everything immediately felt lighter and more bearable.

'I will walk in a straight line from rooftop to rooftop.'

The glowing eyes of cats pierced his blindness, and he advanced, clambering over railings, skylights and chimneys, going up and down narrow iron steps, bumping into wires and more wires, crossing the streets, block by block, via wires and cables.

The rooftops grew gradually more alike and less confusing, and Alfanhuí met fewer and fewer obstacles. Now he required less sensitivity in his hands, and it seemed to him that they were becoming slightly smaller and less painful. The rooftops became large and flat, with barely any gaps between them.

Alfanhuí began to see things again, albeit only

vaguely. It was still dark, but the rooftops had become broad and ridged. Alfanhuí bent down to touch the ground and picked up a handful of earth. These were no longer rooftops, but ploughed fields. He had taken the high road out of the city.

Alfanhuí stopped walking and he began to see. It was growing light. He looked at his hands. They were scratched and covered in blood from feeling his way around. There were other blood stains on his hands too, plum-coloured blood. It was the dye from Don Zana's shoes that had blinded him when he rubbed his eyes. He lay face down on the earth and rested.

PART THREE

I

Concerning the great storm in the mountains

An ancient bird calls out in the dry lands at the foot of the mountains. On the slate walls, by the white road, it croaks and twitches its tail. It steals bread from the carter and pecks at the paint on his cart. It calls out to the cereal crops when it is time for them to ripen. With its voice, it dries the fields in time for harvesting. The other birds leave, but the magpies stay, ancient birds of the Castilian meseta. They denounce heinous crimes and call for revenge for the violated. They recognise individual men and know a great deal of geography. They know what goes on in the villages and on the roads. They speak the names of the dead and remember them without sadness. They recount to each other the stories of the dead. They see the dead pass by on their way to the cemetery and they perch on a stone, describing all they have seen. Men live and grow old; magpies speak and look. The pitiless magpies do not believe in hope; they merely tell the stories of the dead and repeat their names. The dead walk along the mountain road. They are going, like rainless storm clouds, across the dark peaks. Their names linger in the voices of the birds.

The mountain is both silent and full of echoes. Its womb is like the she-wolf's womb, both harsh and maternal. It hides its springs of water in the woods,

139

as the she-wolf hides her teats amongst her fur. The mountain lies down meekly, giving suck to the plains. Only occasionally does it rise up, abrupt and elusive, and tear the lips of the fields.

Above the woods is the bare mountaintop, with its steep scree slopes where the sand in the rivers comes from. The mountain tears open its breast and hurls down avalanches of sharp stones. The mountain has sandy banks in the rivers of the plain, and its eyes close drowsily amongst the sandy bottoms of the pools.

Where the scree slopes end, the heavy brow of the mountain suddenly rises vertically up. Great frightening gargoyles appear, old gargoyles made of rock that stare southwards. They have a protruding lower lip on which vultures perch. Out of their nostrils they distil water and moss, and there tarantulas nest, like sleep around the edges of their eyes. They fix their somnolent eyes upon the plain. The mountains have their faces turned to the south, and it is from that side that travellers know them. The names of mountains are written on the side that faces the sun, and no one knows their shadowy side. In the north they turn their dark, unfamiliar rumps to the north wind. There men get lost amongst the treeless slopes because they do not recognise the mountains from behind. There the mountains do not suddenly end, they spread out in an undulating wilderness.

The great gargoyles were hiding their crests amongst the clouds, amongst the thick, black storm clouds. Below, in the gully, there was still a little light. On the mountain itself it was already night. A

night of clouds blowing in from the north. You could hear the sound of immense horses stretching their limbs. The horses of the storm who gallop across the peaks, striking lightning with their hooves. The lightning shatters the brows of the gargoyles, but their gaze remains impassive. Their greenish-white faces light up in the night, serene and horrifying, vast and yet so close, as if saying:

'We are the guards.'

Down below, in the gully, the sheep continued to advance. You could hear whistling and the tinkle of bells. The small flocks were walking through the gloomy, terrifying day. The shepherds were hastening onwards, casting timid glances up at the black peaks: 'Before the night and the storm swoop down on us like vultures and crush us here on the mountainside.' Behind the sheep came the men on horseback and the women on mules, and the copper cauldrons and the sheep pens and the metal jugs and the saddlebags and the blankets and the trivets and the frying pans. The horses neighed, and the copper cauldrons, sensitive to the lightning, glinted threateningly. And the night and the storm clouds bore down menacingly upon the valley.

Soon the udders of the clouds split open, and the first thunderclap broke, and the gully filled for a moment with blue light. The sheep were terrified. Then the man who was at the head of the procession, reined in his horse, as if to issue a battle order. And he turned back to the flocks and shouted to the shepherds to bunch the sheep together in the middle of the gully. He rode from one side to the other,

141

barking out orders like the captain of a ship. It immediately began to rain, and the thunder and lightning intensified. Amidst the din could be heard the shouts and whistles of the shepherds and the neighing of the horses. It was night and the storm was at its height. One flock scattered and ran straight over the edge of a hill. Two men rushed after them in order to find the sheep by the light of an oil lamp and of the lightning flashes and finish them off, hurriedly skinning them and loading their skins onto a mule. Their nimble knives glimmered in the night as they came and went, flaying the lean shanks, cutting around still twitching tendons, seeking out the soft cartilage amongst the fine bones of the joints. And the smell of blood mingled with the sulphurous smell of the storm. The women were huddled beneath blankets, clutching their children to them.

From on high, beneath the great gargoyles, Alfanhuí could hear the voices of the migrant shepherds growing fainter as they moved down the mountain. But Alfanhuí did not want to retrace his steps and so he turned slightly west, skirting the brow of the mountain, taking shelter in crevices in the rocks when the storm grew too wild. At last, he reached a high pass that cut through the peaks. It was a wind channel along which the north wind blew through to the south face of the mountain. He walked on, lit by lightning flashes, clinging to the rock face, and crossed to the north side.

As if by magic, there was no storm there. The moon silvered the black rumps of the hills, wrapped in their capes. The ground was covered with dark

bushes, like broom, only sturdier and lower, denser and rounder. They were so round they looked as if they had been clipped, like bushes in a garden, and they crouched and quivered in the cold. It was a desert of brown mountains and more brown mountains, inhabited only by those dark, solitary bushes.

Alfanhuí was cold. For the first time, he felt the harsh, desolate cold of the high plateau.

II

In which Alfanhuí recovers and continues his journey

February ended, and by then, Alfanhuí, still on the mountain, had no clothes and was numb with cold. March found him by a fire, where, out of charity, he was allowed to remain for two weeks. The people saw the state he was in and gave him shelter in a hut. Those had been his worst days, roaming the mountains, forced to beg for his living. In the hut, however, he had recovered from the cold and from all his sufferings and had told long stories to the mountain people who had taken him in. When the day came for him to leave, Alfanhuí got up at dawn. The daughter of the family, who was about ten years old, was lighting the fire, blowing on the embers. She had a scarf round her head, thick socks and a rich red apron over her black dress. Alfanhuí went to the door to see what the weather was like. The little girl came and stood by his side. On the threshold, Alfanhuí heard the girl's voice for the first time, because she had not uttered a word until then:

'I know all your stories by heart, and when no one else remembers them, I will, but I won't tell them to anyone.'

Alfanhuí looked at her for a moment and asked:

'What's your name?'

'Magpie.'

'And I will never forget your name.'

145

The little girl burst into tears, covered her face with her hands and raced off to the vegetable patch planted on a bit of high ground behind the house, where there was a fountain and an oak tree. She had a small, weak, sad voice like that of the lambs on the mountainside.

Alfanhuí said goodbye to his hosts, who gave him blankets and shoes for the journey.

'Where are you going?'

'To Moraleja.'

'Is that where you're from?'

'No, but my grandmother lives there.'

He waved to them and left.

In the afternoon, he came upon a snowy field, where he stumbled on two stone markers placed opposite each other on either side of the path and almost buried in snow. He brushed away the snow and read:

SUSANA THE NUN

and on the other:

EDELMIRA THE WITCH

They were two low granite stones, covered in moss. He asked a woman who came riding by on a donkey what the signs meant.

It was something that happened way back. Susana was the beautiful prioress of a convent that no longer existed, and there had been a feud going on between the two women for years, and then, one day, they met

on that spot and killed each other, and the nun fell face up and the witch fell face down, and that was why those markers were there. Gee up, donkey!

And the old lady departed, leaving the donkey's little prints in the snow.

Alfanhuí continued westward for some time and finally began to bear south down the mountain. He plunged into beautiful forests of oak and chestnut and, when he was almost on the edge of the plain, he came across a village. It had stone houses and steep streets. It had springs of sulphurous water that emerged steaming from the earth. Opposite the hot springs was a park in which a huge, round elm tree grew. They told him that the elm tree held the winds captive in its crown and kept them there for seven days and seven nights. Whenever a cool breeze blew by in summer, the elm would trap it and, for a whole week, the breeze would blow round and round inside the elm, unable to find a way out. And the villagers used to sit beneath the elm tree and enjoy the cool of that continually murmuring wind that stirred the leaves as if it were spring. And all the birds in the neighbourhood would perch there too and enliven the evenings, singing and flying in spirals amongst the branches, never leaving. When the seven days and seven nights were up, the wind would grow warm and lose its strength, and the elm would then allow it to leave, dizzy and uncertain which way to go. And that elm tree was never moved by other winds, but, when there was no wind anywhere else, it would pick up a stray breeze that had lost its way and then, when all the other trees in the area were still and

147

languid, the elm in the middle of the park would be gaily swaying and rustling.

That was the last of the mountain villages. Alfanhuí saw the plain opening up before him in the distance, with the winter sun on it, as yet white and weak.

III

Concerning the giant of the red forest

The plain looked bright and cheerful, dotted with
areas of sparse woodland. The earth was brown and
damp with dew. Amongst the clumps of rockroses,
the white flowers with their red flecks were already
opening, and you could see the webs spun by the
yellow spider who lies in wait at the centre. Alfanhuí
saw the outskirts of a forest in the distance. It was a
red forest. The trees had thick, cherry-red trunks,
and their crowns were covered in dark, glossy foliage.
Yet the trees were not tall. The backdrop of red
trunks cast a strange, joyful light on the vegetation
on the forest floor. The ground was very flat and was
covered in short grass and there were a number of
large pools of limpid water only a few inches deep.
The grass grew more lushly on the edges of these
pools, and sometimes one saw white stones or some-
times grey cranes asleep on one leg. The red of
the treetrunks and the green of the foliage and the
lighter green of the grass shoots and the grey of the
cranes and the white of the stones and the glitter of
the pools beneath the blue of the sky formed a joyous
panoply of colour in the middle of that morning
such as Alfanhuí had never known before in other
springtimes. He felt so contented walking through
the wood that he could have wished it would never
end.

149

In the distance, he saw a dark figure. A big man, whose head was as high as the tops of the trees. Alfanhuí approached. The man was tall and sturdy, almost a giant. He had his back turned and had not seen Alfanhuí. Alfanhuí asked him:

'Excuse me, is it far to Moraleja from here?'

The giant whirled round, surprised.

'No, it's about two leagues.'

He was blind in one eye, but his seeing eye was full of light and kindness. He seemed somewhat shy.

'What are you doing?'

Asked Alfanhuí.

'I was just cutting some wood for my fire. I live in that big cabin over there.'

The man pointed to a slightly elevated piece of ground, safe from the pools.

'Do you live alone?'

'Yes.'

'If you like, I'll stay here with you today, to keep you company.'

The man was very glad that Alfanhuí was going to stay with him, and that day, they told each other their respective stories. The man's name was Heraclio and he had been born near there, although his parents were from another region. He had always lived in a village nearby and worked as a cooper. But he didn't do that any more. Once, he had hit another man in the village and, because he was so big, everyone had got angry with him and condemned him to death. They had tried to execute him three times, but each time something happened to prevent it. This they took as a sign that Heraclio did not deserve

to die and so instead they exiled him to that forest, where he worked as a quarryman. He had lost his eye when a splinter of stone flew into it. Heraclio had a treasure, left to him by his parents: two large ivory tusks and two ivory balls the size of melons. No one knew what they were for. But they were a real treasure, because you couldn't sell them. People think that a treasure is something worth a lot of money, but a real treasure is something you cannot sell. A treasure is something that is worth so much it is worth nothing. Of course, he could sell his treasure as ivory, but then it would lose its status as a treasure, and all he would be selling was the ivory. A real treasure is worth more than life, because you will die without selling it. It will never save your life. A treasure is worth a lot and is worth nothing. That is what a treasure is, something that you cannot sell.

Alfanhuí smiled to hear him say these things. The man stopped talking and looked into the distance with his one eye. He saw the agate mountains — brown, white and blue. The sun was sinking in the west. The forest and the distant view were both reflected in the giant's eye. The vigorous, joyful red mingled with the distant, melancholy light. And the stoical deer slowly crossed between his pupil and the horizon, as if in a dream. Weightless, silent and graceful, they moved amongst the red tree trunks and went down to the water's edge.

When night came, Alfanhuí and the giant made a fire. The giant had already cut enough firewood for himself when Alfanhuí had met him earlier that morning. When he learned that Alfanhuí was to be

his guest, he went out again in search of more wood. Thus there were two bundles of wood in the cabin, one for the man and the other for Alfanhuí. They made one pile out of the two bundles and lit a fire. And they talked and enjoyed themselves while supper was cooking. And after supper, they ate and talked and then slept.

In the morning, Alfanhuí shook the giant's hand and they looked at each other fondly. Alfanhuí set off and just as he was about to plunge in among the treetrunks, he stopped for a moment, looked round and saw Heraclio for the last time, still standing watching him, outside his cabin. Alfanhuí left the red forest and set off towards Moraleja.

IV

Concerning Alfanhuí's grandmother

Alfanhuí's grandmother lived in a second-floor apartment which one reached via a courtyard. The courtyard was separated from the street by a wall and a stable door and surrounded on the other three sides by houses. To the right was a narrow stone staircase with an iron balustrade and a vine trellis of moscatel grapes. At the top of the staircase was a long landing, like a balcony, and that too was covered by the vine trellis. To the right was a small door and that was where his grandmother lived.

The room had a low ceiling and very old whitewashed walls covered in lichen. Opposite the door was a tiny window. His grandmother's bed was broad and long and made of dark wood. The bedhead was against the wall on the left. Above the bedhead was an olive branch. His grandmother had placed a rocking chair by the window. There were two flattened cushions on the rocking chair, one for the back and the other for the seat. In the middle of the room was a *camilla*, a round table covered with a thick cloth and with a brazier underneath it, and along the walls there were seven chests. The chests were all different and of different sizes. In one corner, there was a broom and in the other a washbasin on a pedestal. On the wall opposite the olive branch was a black shotgun and a large pocket watch

hanging on a chain. The floor was tiled in black and white.

Alfanhuí's grandmother used to hatch out chicks in her lap. She would be overcome by a fever that lasted for twenty-one days. She would sit in the rocking chair and cover the eggs with her hands. Occasionally she would turn them, but she did not stir from her chair, by day or by night, until all the eggs had hatched. Then the fever would abate and she would feel terribly cold and have to go to bed. Gradually, the feeling of coldness would pass off, and she would get up again and sit at the table with the brazier underneath it. She would have that fever about ten times a year. When spring came, all the children would bring her the eggs they had found in the countryside. Alfanhuí's grandmother would get angry with them because she thought it was rather frivolous to be incubating ordinary birds' eggs in amongst the chickens' eggs. But the girls and boys would come with speckled eggs and blue eggs and brown eggs and green eggs and pink eggs. 'I'd just like to find out what kind of bird it is'; 'I want to rear two turtledoves'; 'The mother bird abandoned them'; 'I found them in my roof'; 'I want to see what comes out'; 'I want to have a little bird of my own'; but the fact is that, in addition to the fifteen chickens' and ducks' eggs that his grandmother used to incubate, there were sometimes as many as fifty of these multicoloured, springtime eggs in her black lap too.

'You cause me nothing but problems!'

His grandmother would declare loudly.

But the real rumpus would take place twenty-one

days later. By eleven in the morning, the staircase and the landing would be filled with boys and girls waiting for Alfanhuí's grandmother to open her door and give them their respective birds. She would keep them waiting a long time, and the children would play and shout in the courtyard and on the staircase. And there were false alarms every time they heard her move about in the room, 'She's coming, she's coming!', and the wait would seem endless. Finally, around midday, she would open the door. They would all crowd round the entrance, pushing and shoving so as to be the first. She remembered which egg belonged to which child, and she never made a mistake. The children would stand at the door, and she would begin handing out the birds: 'Here are your turtle doves'; 'yours was a cuckoo'; 'yours is a song thrush'; 'yours is a swift'; 'yours is a sparrow'; 'snakes hatched out of yours', and the child would hold out his or her hands and take away five little black snakes. Because it was too bad if you didn't like what came out of the eggs, you had to take it whatever it was. Nothing so angered Alfanhuí's grandmother as fussiness.

'What do you mean you don't like touching them? I've kept them warm in my lap for twenty-one days, so you'll just have to put up with it.'

And on she would go: 'yours were mistle thrushes'; 'yours is a goldfinch'; 'yours are lizards'. The courtyard rapidly became an exchange market. And if one had wanted a lark, but hadn't got one, he or she would find someone who had and propose a swap. And there would be quarrels and uproars. And

Alfanhuí's grandmother would get angry again and shout at them:

'I want no arguments in here. Out into the street with you!'

But it was no use. 'Yours had nothing in it, it was empty,' she would perhaps say to a little girl with a big white ribbon in her hair, and the little girl would leave weeping bitter tears, her basket empty. But Alfanhuí's grandmother would be quite unmoved. When it was over, she got angry again; having patiently incubated the eggs for twenty-one days, she would suddenly grow indignant:

'And don't come back! Not ever! It's the same thing every year, and you never give a thought to me afterwards, you never even bring me a cake or come and see me. Out with you! I won't do it again next year, you'll see.'

But 'next year' in the spring, the grandmother would be glad she was still alive, and the whole business would start again.

Alfanhuí's grandmother was tall and thin. She had white hair which she never combed. She dressed entirely in black and had a woodworm living in her calf. The woodworm was slowly eating away at the bone, and at night you could hear it gnawing. But her tibia was so hard and so dry that the woodworm's work was never done. She would rub the spot with a cloth soaked in a tincture of thyme and cypress, and the woodworm would fall asleep. That is why her calf was all green. She never went out, but everyone came to visit her. The apartment downstairs was hers as well, and she rented it out. Her tenants cooked for her and looked after her.

That was the life led every year by Alfanhuí's paternal grandmother, the one who incubated chicks in her lap and had a vine trellis of moscatel grapes and who never died.

V

*Concerning the jolly village of Moraleja and how
Alfanhuí and his grandmother met*

Alfanhuí arrived in Moraleja. The village was built
on a plain, on the banks of a river. The houses were
painted red ochre, orange and indigo. The frames of
the doors and windows and the corners of walls bore
a stripe of white lime. Some houses were decorated
from ground level to head height with glazed tiles in
various colours or by tiles with designs on them. The
tiles were rhombic in shape and arranged vertically.
But on the older houses, the tiles were unevenly
placed, in odd patches, with four here, ten there, one
over there, like a skin disease. The history of the
houses was written on the walls in anecdotes told in
coloured tiles. It was a silent, hieroglyphic tale.
Every householder had his tile there, his place, his
part in the design. When someone dies, their tile
might fall, breaking into a thousand pieces on the
cobblestones. What remains is a newly created space,
rough, still raw. Then time wears it away, softens it.
Sometimes the tile might be replaced or the space
whitewashed over years later. And if someone then
thought: 'It's odd, you know, when so-and-so died,
that tile fell off', that person would hold the key to
the hieroglyph. But no one ever spots the coinci-
dence, and everyone continues to see the wall as
completely meaningless, as empty and random, not

159

even mysterious. Time, however, has written its stories there.

The streets were full of people. They came and went, enjoying the sun. In Moraleja everyone was very talkative. They would take their chairs and washbasins out into the street. On ground-floor windowsills there would usually be a comb and a tablet of perfumed soap. Sometimes, suspended from the iron grille, there would even be a mirror and shaving gear. A small, brazen mirror that stared at the passers-by with its white, insulting glitter. The people of Moraleja washed in murky water, which is why their faces were blurred and their features vague.

When they grew angry or were happy, their expression shifted slightly, like clouds changing shape. They would talk and would seem to be looking somewhere else, although not even they knew where exactly. They wandered about distractedly, idly, as if they had no purpose in life.

The dogs of Moraleja were scraggy and mean-tempered all year round and formed a wily, inconstant community. They went about in groups looking for scratching posts, taking it in turns to scratch their scrawny ribs. They fought amongst themselves and bared their teeth at people. Scraggy and mean-tempered all year round, they would feast on figs in September. There would be four, six, eight of them underneath a fig tree, and they would stay there until their bellies were tight as drums. And then they would lick themselves and sleep out the siesta in the shade of the stone walls. The fig harvest

lasted a month, and in Moraleja the dogs did the harvesting. There were figs of many types – white, purple, black and green.

Moraleja ended on the shores of the river. Along the shore ran the last street with just one row of houses; on the other side of the street was a parapet, sixteen feet above the water, although the water was sometimes lower. All the houses were reflected in the river. A high, black wall acted as a flood wall. That was the way out of the city, across a narrow bridge with a wrought-iron railing. Below, you could see the deep river cleaving to the wall on the city side. On the other side, though, there was a beach of round pebbles that sloped slightly up to the trees above the shore. From the bridge you could see a watermill downstream and, in summer, naked boys on the wall of the dyke. Their shouts and the noise of them diving into the water could be heard from the bridge. And from there you could see clothes and sheets laid out to dry on the smooth stones and on the spurge bushes. On the other side of the bridge was the wood. There were elms and eucalyptus trees and an inn selling wine and fish, with its vine trellis and table. The table was a great slab of slate on a stone base, and around it were four benches also made of long, blue slabs of slate. It was an inn for beggars and orphans, fishermen and carters. Chickens pecked around their feet. As well as the house, the innkeeper and his wife owned a cat, two goats, a boat and a shotgun.

Alfanhuí walked back from the bridge and went looking for his grandmother's house. Alfanhuí and his grandmother had never met. He asked at the

ground floor apartment. A girl ran up the stairs, shouting:

'Your grandson's here, Aunt Ramona! The one from Alcalá de Henares, the one who lives with his mother by the mill, the son of Gabriel, may he rest in peace!'

'There's no need to explain, I've only got the one grandson! Stop making such a fuss and tell him to wait.'

His grandmother locked the door. She got out a blouse and skirt, a shawl and a scarf. Everything was black and had the damp, clean, old smell of things stored in chests. The blouse was fastened by a row of small buttons, very close together. The sleeves were full, but tapered into the cuffs. His grandmother buttoned the cuffs over her slender, bony wrists. She did up the black wire hooks of the skirt around her slim waist and arranged the skirt so that it fell in vertical folds from her hips. She put the black scarf over her dishevelled, white hair and the shawl over her shoulders. Then she went out onto the landing, her hands clasped, and looked at Alfanhuí as he came up the stairs. When he got to the top, she stood to one side and said:

'In you go.'

Then she went in too and shut the door behind her. She sat down on the rocking chair and began to speak. Alfanhuí remained standing up, looking at her.

'Did you want me to die without seeing you? Ungrateful child, never once visiting me. Stand in the light where I can see you. . . . Hmm, white-

skinned and sturdy like your grandfather. Every night I used to say to myself: "I wonder what that grandson of mine is like, that bird who never deigns to fly over here? I'm going to die as if I'd never even been a grandmother." And in August and September when there were almonds and hazelnuts, and in October, when there were chestnuts and walnuts, which I couldn't eat, I would remember you and think: "My grandson could bite into these." Every year I would save them for you until they were so shrunken and shrivelled I had to throw them away. A fair few good handfuls went to waste with no one to eat them.'

'I can stay with you now, grandmother, if you'd like me to. I can sleep downstairs.'

'Of course you'll stay! I could hardly send you away now! And you'll sleep with me in my bed. I take up no more space than a broomstick.'

It was growing dark. His grandmother told Alfanhuí to close the window and light the oil lamp hanging from the ceiling above the table. Then, without getting up, she dragged her rocking chair over to the table with the brazier underneath it.

'Pull up that bench and come closer.'

'Grandmother, if I stay longer than a year, I'll have to find a job.'

'What can you do?'

'I'm a journeyman taxidermist.'

'Well, we've no time for nonsense like that around here. That's no good. People who work here can expect a lot of sun and a lot of rain, a good soaking now and then and plenty of bad weather. That

taxidermist business is for fanciful people who enjoy having dead animals round the house. Not here. But I'll find you a job, don't you worry. Are you cold?'

'No, Grandmother.'

His grandmother continued talking:

'And I was always saying to the neighbours: "My grandson this and my grandson that." And sometimes they would ask me what you were like, and I'd feel really sad then and be ashamed to have to tell them that I'd never even met you. I think they all began to doubt you even existed. How I longed to be able to say to them: "Here he is." Because all the other grandmothers in town have got ten or even twelve grandchildren. Come over here, stand closer so that I can touch you ... You've got good calves, walker's legs. So why didn't you come and see me sooner?'

His grandmother fell silent for a moment, and Alfanhuí looked round the room and asked:

'Grandmother, what's in those chests?'

She looked at him and said sharply:

'None of your business.'

VI

*How Alfanhuí became an oxherd and concerning the
twelve oxen in his care*

His grandmother soon found a job for Alfanhuí. She
didn't consult him about it, she simply said:

'Tomorrow you'll go down to the meadows with
the oxen.'

And Alfanhuí, who didn't mind one way or
another, accepted gladly.

Moraleja, being an ancient village, had its ten or
fifteen ancient oxen. 'The village oxen,' people called
them, because, although when the oxen were young,
people would say they belonged to this man or that,
now that they no longer wore a yoke, worked the
fields or pulled a cart, no one claimed them as theirs.
They were old retired oxen, black or brown, with
large eyes and deep, dark pupils, a long, rhythmically
chewing jaw, a slow gait, and an immutable, infallible
homing extinct.

'Always take the goad with you and keep the point
sharpened, but treat the oxen with respect and never
hit them or threaten them, because they know their
route and they know which meadow to be in at which
season, and they know more than you or I do about
any dangers.'

That is what the old oxherd said, and Alfanhuí did
not ask why, if the oxen knew so much, did anyone
need to accompany them and carry a goad and keep

it sharpened. He understood the noble custom of
allowing the oxen who no longer ploughed to con-
tinue their lives, to respect their old age, but main-
tain their dependence. The oxen were useless, so was
the oxherd and so was the goad: the oxen did not
serve to plough, the oxherd to lead or the goad to
prod. It was a custom typical of these ancient
villages.

And so Alfanhuí became the oxherd in Moraleja,
earning twelve *reales* a day. There were twelve oxen
too, and the oldest was called Caronglo. He was big
and black as a cave and, like a cave, his belly was full
of the arcane rumblings of dark waters. His eyes
were large, gentle and moist. And he had a cold, wet
snout. Slow strings of saliva hung from the edges of
his mouth. His skin grew in folds over his eyes,
around his sturdy knees and where his legs met his
chest. His horns were old and warm and, at the base,
there was a polished, shining border where the har-
ness straps had fitted, and his neck had been worn
bare and hard by the yoke. Above all, his breath
when he snorted was white, like a fine winter mist
that melted the frost or clung, damp and odourless,
to the thornbushes. His hoofprint was as large and
distinct as that of some swamp creature, and was
instantly distinguishable from all the others. His
companion was Pinzón, who was not quite as dark
and had a white stripe along his back. The other pair,
Marrero and Charrián, were brown and had mis-
chievous eyes. The following were black: Ariza and
Turino, small and brave, and Almadrán and Retana,
who had once ploughed stony fields. Jaso and

Almeira were brown, dark and stocky as heifers, and had once belonged to a Portuguese man. The last two were black: Gago and Sonsoles, who had been used to draw carts.

Each morning, Alfanhuí set off with the oxen to their pasture and he either ate his lunch in the field or, if the old oxherd came to relieve him, went up and had lunch with his grandmother. In the afternoon, half an hour before the sun set, he would go with the oxen back to a walled enclosure, open to the sky apart from a roofed area on one side containing feeding troughs carved out of the trunk of an oak tree. The oxen could go in there if it rained. Alfanhuí soon learned to recognise them and they him, and, in the morning, as soon as they saw his head appear above the wall, they would move towards the gate for him to open up for them. And they would greet him with a soft lowing that issued from deep inside their large nostrils. Alfanhuí would scratch their foreheads or stroke their horns. The last to come out was always Caronglo, who would place his wet snout between Alfanhuí's hands and sniff them.

Alfanhuí would skip along in front of the oxen or stay at the back beside Caronglo. When they had to cross a mire or the river, Caronglo would wait on the shore and Alfanhuí would climb onto his back. Later, Alfanhuí grew so fond of this that he wanted to ride on the ox's back all the time, enjoying being high up, rocked by that slow, undulating gait. And soon, on the journey there or back, Caronglo would not budge until Alfanhuí had clambered up. Alfanhuí would

carry the goad on his shoulder, bestriding the ox's black flanks with his thin, white legs.

In summer, when the oxen went down to drink and graze by the river, Alfanhuí would bathe. He would plunge in naked and start swimming. He would dive down and pick up red, white or blue pebbles or tiny green, flecked ones. Sometimes he would swim underwater to the shore and kiss the black snouts of the oxen while they were drinking. Or he would call to them from the middle of the river and duck down when they turned round: 'Gago! Retana! Pinzón!' Then he would burst to the surface again, and his laughter would echo brightly across the water.

VII

Of fishermen and hunters

There was in Moraleja a man who had seen the sea. Alfanhuí met him one day when he passed by his hut. This was situated in a copse by the river, near where people went to fish. The man's name was Pablo and he made trammel nets for fishing. He had made nets by the sea and now, an old man, he had returned to Moraleja. He was also a boatman and had a raft for when the river flooded. He lived alone, and the light from his lantern could be seen in the darkness, amongst the trees on the other bank, shining out from his open door, which looked out on to the river. He liked to tell his story. How in the ports, there were certain murky, blue-grey days that fell to the ground like the jackets of suicides. From the pontoons would rise the black song of the stevedores calling to the squid and the crabs in the bay. And to the carpenter crabs who scratch at the old timbers of the port and scamper sideways across the bellies of the barges. The sailors inside can hear them, and a shudder runs through them, like a sudden zigzagging crack. Death works away, opening up crevices in souls and in names. A red branch rises to the bloody tree of the pupil. To the tree of the eyes, melancholy as a Japanese cherry tree. Pablo would speak of a bitter death unknown to the men of the plains. And every-one would listen with morbid interest, strangely

attentive. Inland, death is lighter; it walks the glass plains in white vestments.

Alfanhuí would watch the shuttle going back and forth, forming stitches beneath the man's hands. And Pablo would speak only occasionally, slowly, as if talking to himself. He kept a restless, dark fire, full of blue flames. There was a shallow earthenware pan by the fire containing a thick, brown stew that gave off a pungent smell. It was snail stew. Pablo always ate snails whenever he could. He collected them, after the rain, from an old wall covered in creepers. Once in the pan, the snails jigged and jostled in the bubbling sauce.

Outside, in the darkness, a long whistle sounded, coming from the river. Pablo left his work, got up and lit his round, golden lantern. Then he went over to the open door and, his arm stretched out to the river, he raised the lantern three times. Another whistle answered him from the darkness. Pablo went back in, hung up his lantern by the fire and resumed his work.

'It was the fishermen out in their boat.'

There were a lot of fishermen in Moraleja, three leagues downriver. They had primitive boats built in the shape of elongated rhombuses. They fished for barbel, mullet and eel. There were also rod fishermen who bred tench in ponds, small green ponds with algae at the bottom, used as watering places for cattle. Some were for breeding, others for fattening the fish up. The pond where they bred the tench was no use when it came to fattening. They removed the young fish from there at the end of spring and carried them to the other pond. Then they would catch

all the fish in September and sell them at market stalls and refreshment tents. They would slice them into three and cook them in a lot of salt so that they required a great deal of wine to wash them down.

On summer nights, others went fishing for frogs with an acetylene lamp.

Alfanhuí preferred going on expeditions with the fishermen rather than with the hunters. But when it came to talking, he preferred the hunters. There were two very amiable, well-known hunters called Luquinas and Galán. Galán had emigrated to Buenos Aires as a bricklayer and returned a wealthy man. With the money he brought back he had opened a club in Moraleja complete with gaming tables, pocket billiards and two of those one-armed bandits – the oranges-and-lemons variety. Galán was an extremely fit and jolly fifty-two-year-old. He was thin and quite tall. He was a fast, voluble talker, with a loud, gruff voice, and he packed the club with punters with his knowing winks and his raucous laughter. Galán was still very proud of his former trade and would embarrass young bricklayers by stopping at building sites and insolently inspecting everything, always finding fault and often picking up the tools himself, saying: 'That isn't how you do it; you do it like this. Give me the spirit level! Hand me the plumb line. Now the plaster!' and in a matter of minutes he would have dismantled the whole wall and started again, while the bricklayers timidly watched and listened. Then he would put his hat back on and leave. The bricklayers tried to make excuses.

'No, no excuses, you're just shoddy workmen!'

171

Luquinas was about thirty-five, short and stocky, with very pink skin and a head of sparse fair hair. He too was a jolly, playful fellow and took it in turns with Galán to crack jokes. Luquinas' laugh was soft and insistent as a cough, a guttural noise in the back of his throat, entirely lacking in vowels; indeed, it made the perfect partner for Galán's loud, sonorous guffaw. They would go anywhere to hunt, always setting off with great enthusiasm, and even if there wasn't a creature to be seen, they would convince their wives that they would bag at least twenty-five hares. But they were all talk. Later, up in the hills, they would drink wine and fire off shots to right and left, frightening off what little game there was with their continual chatter, and Galán would burst out laughing at the slightest thing, making the country-side echo to the sound of his laughter. Around four o'clock, they would get bored with shooting and, in some cabin in the hills, they would get out a deck of cards and start a game of quinze and continue drinking large quantities of wine with the local game wardens. At the height of the merriment, Galán would lean back in his chair, push back his hat and sing in impassioned tones:

'Caresses, the sound of kisses . . .'

The song never went any further, but Galán put such passion into the words and into raising his glass that he evoked for everyone some far-off foreign land full of pleasures and marvels. Luquinas, meanwhile, would be embroiled in an argument about local politics, though he would be arguing with the air because no one ever contradicted him. He would,

nevertheless, get very worked up and insist he was in the right. And so on until the sun set and it grew dark. They would arrive back, singing, in Moraleja at nine o'clock, having completely forgotten all about hares and partridges.

Galán would put down his rifle and his hat and start to serve his customers. One would ask him:

'What about those hares, Galán?'

'Don't talk to me about hares!'

Meanwhile, Luquinas would be sitting at a table still arguing about local politics.

VIII

Concerning the fire, certain stories, his grandmother's chests and Alfanhuí's desire for a pair of boots

Instead of a fire, his grandmother had a brazier, of the sort placed under a round table, which was in turn covered by a thick cloth. She would go out onto the landing very early in the morning to light the brazier and would spend a while stoking it with a cane. Then she would cover it up with the previous day's ashes which she had pushed to one side while she was lighting the new coal. Thus his grandmother piled one day on top of another and threaded them together on that rope of ashes. It was a coal brazier that smelled of greyness and sometimes of incense. She never used a poker, and whenever the embers died down and gave out little heat, without lifting the thick folds of the table cloth or even looking down, she would make the sign of the cross with her slippered foot. And when Alfanhuí felt the fire glow hot again, he would be surprised, because from the waist up his grandmother appeared not to have moved and continued to talk blithely on.

When Alfanhuí became more familiar with his grandmother's fire, he wanted his grandmother to tell him stories, and to do so, he resorted to a trick. He brought back from the fields a few sprigs of rosemary and surreptitiously threw them onto the fire. As they burned, their fresh scent would fill the

175

air, and his grandmother, without realising, would begin to tell stories. She described her girlhood, when she used to dress in white and green. Alfanhuí would get so interested in the stories that he would forget to throw more rosemary on the fire, and his grandmother would gradually fall silent. As soon as Alfanhuí realised this, he would throw on a few more sprigs, which would stimulate his grandmother into continuing her tales. However, Alfanhuí did not want to overuse the rosemary, because stories lose their savour if too many are told in one day. When the bittersweet smell died away, his grandmother would say:

'Right, that's enough for one night. I'm not telling you any more. Now don't insist, it's time for bed.'

And Alfanhuí, the little thief of stories, would smile mischievously to himself.

Then they would snuff out the candle and get into bed. It was a wide bed, but sometimes Alfanhuí's foot would collide with his grandmother's foot, which was so cold it made him jump.

On some nights, his grandmother was very restless in bed. She would toss and turn as if she had something on her mind that would not allow her to sleep. Then she would get up in her nightshirt and, without putting on the light, go over to the chests. He would hear the clink of the keys that she carried round her waist, underneath her nightshirt. Alfanhuí could just make her out in the darkness. His grandmother would take out her bunch of keys and open one of the chests, and he would hear the rattle of the key in the lock. His grandmother would lift the lid of one of

the chests and the hinges would creak. His grand-
mother would take something out and put it in one
of the other chests. He would hear the sound of that
something and of the second lock. Each chest emit-
ted a vague light, soft and phosphorescent, greenish
or blue in colour, or pink or white. Then his grand-
mother would begin going from chest to chest, taking
things out and moving them elsewhere, opening and
closing. Sometimes there would be the sound of silk
or silver or paper or glass or leather, and he would see
the things glimmer in the darkness. Alfanhuí tried to
identify each thing by the glow it gave off or by the
noise it made, but his grandmother, absorbed in her
dance, never left enough time for him to do so. It was
merely a sprightly flickering of tenuous lights in the
dark and a concerto of keys, hinges, locks and lids
being closed, the clink of objects, the rustle of
fabrics and papers, and each chest had its own light,
its own distinctive note. So much so that, after many
nights of hearing his grandmother taking things out
and putting things back, Alfanhuí learned to recog-
nise everything by the noise it made and by the
way it glinted, although he never actually knew
what the things were, and he would say to himself
in the darkness, as his grandmother was removing
something or other:

'That was in the third chest, and now she's moved
it to the seventh one.'

And he would remember for the next time and
would follow the trail of each object, although he
never found out what that object was. Afterwards,
his grandmother would get back into bed, deathly

177

cold. But sometimes, she could still not rest easy because something was not quite right, and she would get up again and change everything around. There were nights when his poor grandmother would get up two, three or four times and would not rest from her labours until the cocks crowed at dawn. Alfanhuí never asked his grandmother about these reorderings, these putting-ins and taking-outs, and she never mentioned them either.

When winter came, Alfanhuí found that his feet got terribly cold in espadrilles and got drenched whenever it rained. He mentioned it one night in bed:

'Grandmother.'

'What?'

'I'm going to have to buy some boots.'

'Why?'

'Because the ground's really cold and my feet get wet.'

'But you're a young man, and there's always a good fire here.'

'Yes, but I don't get to enjoy the fire until the evening and, during the day, however much I rub them, my feet just never warm up.'

'Boots are bad for you. They don't let your feet breathe and they give you corns.'

'But my feet can breathe at night in bed. During the day, they need blood in them and they get so cold that the blood drains out of them and they turn white.'

'Well, you are white, aren't you? And so was your grandfather. That's the natural colour for feet to be.'

'My grandfather wore boots.'

His grandmother thought for a moment:

'What do you know about what your grandfather wore?'

'My father wore boots too and he was a young man.'

'Your father was a good-for-nothing. He climbed up onto the roof one day, and I had nothing but leaks from that day on.'

'He had two pairs of boots.'

'Rubbish. You're not having any boots, so go to sleep!'

In the morning, Alfanhuí went out to the fields resigned to having feet like ice. But in the evening, when he came back, his grandmother had changed her mind. When Alfanhuí sat down, his grandmother, without saying a word, placed in front of him a pair of large old boots. They were his grandfather's black boots. They had no laces in front, and elastic at the sides. They were like boats on Alfanhuí, but he didn't dare say as much, and so he greased them with fat and happily wore them all winter. They were the first thing to emerge from the chests.

IX

*Concerning the drummer from La Garganta and
Caronglo's venerable death*

And that winter, during which Alfanhuí went with
his oxen to the broom thickets, also passed. It was
not quite so cold there because the broom took the
edge off the wind, which was dispersed as it whistled
through the broom needles. In spring, the drummer
from La Garganta came down through the oak
woods. The wind's high-pitched whistling wove
through the ilexes, and the drum made the ground
throb, waking the sleeping lizards. The drummer
entered the broom thicket. Alfanhuí, sitting on a
stone, saw him from afar and heard his music as he
approached. The drummer threaded his way through
the whistling bushes, his feet keeping time to the
beat of his drum. Sometimes there was just a soli-
tary, fading whistle, like some long, ancient wound in
the wind; sometimes, the drum would burst forth,
like a corpse rising proudly and joyfully up, and it
would wind up the loose, fast-fading thread of the
whistling, as if it were the thread of life itself. The
whistling and the drumming played at anger and at
sadness, at being lost and being found, at forgetting
and remembering, at living and coming back to life.
One moment near, the next far away, one moment
rising, the next falling, coming and going, taking
the exact measure of the fields and the paths.

The drummer passed by. Now the song would move off again, with the final notes. Alfanhuí saw the drummer's back disappear amongst the broom.

That same day, the oxen left the broom thicket and changed pastures. They were going to a treeless field at the far end of the meadows, where the unirrigated land begins. One evening, when it was time to go back, Alfanhuí could not see Caronglo anywhere. The other oxen were heading back towards Moraleja, but there was no sign of Caronglo. Alfanhuí went to look for him. It was nearly dark when he found him lying on the ground in a quiet place near a spring. In Caronglo's nostrils he could hear the breath of the dying. Alfanhuí sat down by his head and took hold of his horns. Caronglo placed his snout against Alfanhuí's chest and sniffed him as he always did. Caronglo's breathing was becoming steadily slower, deeper and more laboured. Alfanhuí felt Caronglo's horns growing cold. At last, Caronglo opened his eyes very wide, his eyeballs rolled back, he blinked once or twice and then, closing his eyes, his head slumped heavily into Alfanhuí's lap. In the darkness, Alfanhuí looked at the head and body of the dead ox, black against the earth, and he seemed to him even bigger than ever. Alfanhuí remained there thinking for a long time, stroking Caronglo's head, feeling the sweet, almost joyful sadness of a natural death. Suddenly he looked up and saw that the other oxen had come back and were standing round them. They formed a neat circle. Pinzón began to bellow in a low, deep voice. Then the other oxen answered him. Pinzón again uttered a solitary bellow. The third

time he did this, a shadow in the shape of an ox rose up and got to its feet – the body of Caronglo, the shadow that Caronglo had cast on the ground when he was alive. Alfanhuí stepped aside. Caronglo's shadow began walking away surrounded by the other oxen, who continued to sing their funeral lament, monotonous as a psalm. They all headed towards the river, and Alfanhuí followed. They moved slowly to the rhythm of those prolonged bellowings. Pinzón went ahead of the shadow and the others walked beside or behind. At last, they reached the bank and stopped. They fell silent for a moment, only to take up the song on a different note. Then Pinzón moved to one side, and Caronglo's shadow walked into the water. The oxen stayed on the bank while Caronglo plunged slowly into the river. The water reached his knees, his belly, his chest. Caronglo's shadow was gradually being swallowed by the waters. The current began to take hold. The oxen continued their psalmody from the shore. Finally, Caronglo's neck and back went under, then his head and, finally, his horns, the points of which vanished beneath the ripples. The oxen sang on for a while, leaving upon the waters one last, long lament. Then, slowly, they turned and went back up to Moraleja.

X

*How Alfanhuí said goodbye to his grandmother and
returned to Castile*

In March and April his grandmother's fevers and
various tasks started up again, and in May, his
grandfather's boots were returned to the chest.
Alfanhuí put on a pair of sturdy espadrilles and gave
his grandmother half of his money.

'Goodbye, Grandmother Ramona!'

Alfanhuí now had the summer and the road before
him and he crossed the mountains to the north, back
into Castile. The roads were full of birds and travel-
lers, of the first harvesters coming down from the
north for the early barley, of ox carts or mule carts
that stopped at the roadside inns with their loads of
charcoal made from oak or cork. As the song says:

> Ah, fair Salamanca,
> Who pays your way?
> A few charcoal burners
> Who work night and day.

The charcoal burners were shy men of few words
and, because they were always covered in black dust
and because no one ever tried to steal their goods,
they felt they were the lowest of the low. At inns,
they formed their own obscure group in one corner,
or, if there were other travellers staying, they would

go outside to smoke and watch the moon shining on the road. The landladies scornfully poured out their wine because, in summer, every poor wretch is out wandering the roads. Even the harvesters meant little to the landladies, however far they had come. They were all very careful people who only ever ordered wine and never left a tip and whose bones required neither bed nor comfort. Alfanhuí often came across such groups; usually they had only two donkeys between four people. They were small, lean men who carried their sickles tied to their saddle bags and wore dark clothes and bright, white shirts. Alfanhuí had never seen anything as free or as clean as the harvesters' white shirts, the open-necked shirts of the poor, with sleeves that puffed out in the wind revealing hairy, bony arms. The white shirts and the sad, long-suffering look of those who harvest other men's fields. They were the slaves and the masters of the whole wide summer.

All roads pass through the town of Medina del Campo. She is like an ample lady sitting in the middle of the Castilian meseta; she spreads her skirts over the plain, over that rich fabric painted with fields and paths and embroidered with cities. Medina del Campo has four skirts: one grey, one white, one green and one golden. Medina del Campo washes her skirts in the rivers and changes four times a year. She gathers them slowly in, and the four seasons begin and end in her. When the summer comes, she spreads out her skirt of gold. 'Come on, it's time for you poor people to go back on the roads!'

From Medina del Campo northwards, Alfanhuí

walked many more days beneath the sun and the moon. Beneath the large, luminous moon of the summers which walks sideways like an owl on a wire and sets the plains winking. The milestones dance like ghosts, flickering like white flames, their shadows dancing on the ground. In the shadows of the milestones, the devil sometimes sits, counting on his fingers the sins of man.

Alfanhuí finally reached a land of bleak plateaux. The plateaux rose one after the other like round, white drums. They had a slope of about one hundred and thirty feet and on top a flat slab of white limestone dotted only with gaunt bushes and the rotting corpses of hares and greyhounds. Between each plateau were clear valleys through which snaked the river, bordered by tall, thick woods. Otherwise, the valley was cultivated in small plots. Each plot had a stone bearing a name. Alfanhuí read one such stone, marking a plot of about a quarter of an acre:

<div align="center">ROQUE SILVA'S FIELD</div>

Roque Silva was there, contemplating his ripe crops.

'Look how well it's done, just look! I'll come up with my scythe tomorrow and set to work; it'll be done in no time at all. There's not another field like mine in the whole of Cerrato; it's just a shame it's so small; but I might get a clutch of partridges out of it, because I can hear them calling all the time.'

And Roque Silva laughed, and Alfanhuí looked at him. Roque spoke again:

'Are you on your way to Palencia? You'll see it

below you if you go up to the far end of that plateau. One year, someone from Palencia, a fellow with glasses, brought a lawsuit against me and tried to take my land away from me and make me even poorer than I am. But I won the case, and with no help from anyone. I wasn't going to go down without a fight! But, anyway, you're probably in a hurry.'

'Goodbye, Roque Silva, and thank you.'

'Goodbye, my friend, and good luck.'

And Roque Silva turned back to admire his crops again.

XI

Concerning the city of Palencia and Don Diego Marcos's herbalist shop

Palencia was a bright, welcoming city. Its doors stood wide to visitors, a city as easy to break open as a new loaf of bread. The sunny main street had a colonnade of white stone. The towers too were white, stocky and strong, and the river broad and full. On the other side of the river there were water meadows, which were planted with vines, vegetables and fruit trees and scored with canals. Up and down the canals moved barges drawn along on ropes by mules whose hooves slipped in the mud. In the setting sun, the water in the canals was a languid, fertile whitish-blue with touches of green and red.

Don Diego Marcos's herbalist shop was in the main street and contained the same glass and porcelain jars to be found in pharmacies. Above it hung a black sign on which was written in metallic paint:

MEDICAL HERBALIST
DIEGO MARCOS

Diego Marcos, a graduate in Natural Sciences, was tall, stout and arrogant. He wore gold-rimmed spectacles and a faded ochre yellow overall. His wife worked behind the counter with him and she too was fat and presumptuous. A kind of pharmacist's

189

assistant also wandered about the shop, a beardless, emaciated youth of about twenty-five. The shop itself was gloomy, and all the shelves were made of varnished wood so dark it was almost black. The shopwindow was full of jars and dishes of herbs, each with its own label, on which one could read:

SWEET MARJORAM; WILD PINE; ARENARIA RUBRA; COMMON LUNGWORT; BEAR'S EARS; BLACK NIGHTSHADE; CAMOMILE; PEPPERMINT; PENNYROYAL; BELLADONNA; CORDIALS; MARSH MALLOW, ETC. ETC.

Alfanhuí went to work in the shop, in an even lowlier position than that of the assistant, ordered about from pillar to post at all hours by the owner and his wife. Alfanhuí said nothing and learned. He took his meals with the assistant, who treated him rudely and contemptuously, and he slept in the back room of the shop amongst secret, hidden jars that contained in their hearts all the perfumes of the mountain. Hanging from the walls were large sheets of shiny paper, with a black pole at either end, so that the sheets could be rolled up; these contained coloured drawings of plants with the leaves and flowers separated out, along with sections of the stem and roots to show their special characteristics and to allow one to study the vessels and the tissues. Underneath were labels bearing words such as 'Monocotyledons' and, in still smaller lettering, 'Llosent Printers, Barcelona'. In the middle of this room was a large marble-topped table with a pair of scales secured to it with

190

screws. In one corner, beneath a hexagonal clock, was Alfanhuí's narrow bed. On the floor were small open sacks containing the herbs most commonly used and which lost none of their potency with exposure to the air.

Alfanhuí already knew something about these things and was familiar with the names and properties of many of the herbs. But now he was looking to improve his knowledge and he would sit with his eyes glued to the glass cabinet; he would take out the jars and smell them and sift the herbs through his fingers and, when no one was watching him, prepare infusions and strange distillations. He would consider the names of the herbs too and say them over and over, as if trying to find in them the echo of old stories and what the actual appearance of each plant had meant in the lives and hearts of men. Because the names by which we call them are not the true names of the herbs that lie hidden in the seed, too sacred to be spoken, but have been chosen for some quality that the eyes and hearts of men have recognised and which sometimes carries in it an accurate echo of that other name which none can speak. Alfanhuí would say the names over and over, and some were better and some were worse. There were foolish names that said nothing, and there were mysterious names in which he could hear the whole mountain speak.

The herbalist used to send him into the country charged with bringing him some particular herb he was running short of, and he would indicate to him more or less where it grew. Some were abundant and

others rarer and more difficult to find. But Alfanhuí, merely from having seen and smelled the herb in its jar and learned its name, could already imagine the place where it might grow and he developed almost a sixth sense when it came to finding it, even though he had never seen the herb growing in the wild. And he would go up to the hills and gaze down on the different colours of the earth, to see where it was sandy or limy and where there was more water or less and which were the prevailing winds and which parts were sheltered and which sunny or shady or sloping and all the other infinite factors that made the land so various and difficult. Alfanhuí would close his eyes in order to see all this, because he found it best to rely on intuition and instinct rather than intellect. Sometimes he had to travel very far and to spend the night in the open. But he always came back with his bag of herbs over his shoulder and some new and rare plant he had picked for himself.

XII

*Concerning the newest and last piece of wisdom to enter
Alfanhuí's eyes*

As he worked with the herbs, Alfanhuí became silent
and solitary. His eyes took on an absent, vegetable
look, as if one strange, tiny leaf had been drawn a
thousand times on every segment of his pupils.
Alfanhuí had placed in his own eyes, in front of his
memory, something green and botanical that hid him
from men, so that everyone who looked at him
thought him dumb and absent.

His eyes now were like pale, dense forests, mono-
tonous and lonely, where everything was lost. And
the light fell obliquely and, as it shone through the
leaves, grew silent and slow or rested briefly in the
clearings amongst the trees, lending the forest, with
its succession of different frontiers, a deep, endless
perspective. And from the depths of that hetero-
geneous silence, Alfanhuí was pondering his new and
multifariously green wisdom.

Immersed in this new speciality, Alfanhuí worked
day and night, whether with his eyes open or with his
eyes closed. By day, he would study the herbs in their
dead form in the herbalist's shop and in their living
form in the countryside. And he would lie on the
ground, with his elbows digging into the earth and
his head in his hands, observing for long periods the
minute shoots of plants. Or, at night, he would

patiently analyse them in the dark, because he could
see them there in his memory, as large as he liked and
he could study each detail and dissect their colours if
he so wished, in order to know them better.

Thus Alfanhuí gradually discovered the four main
ways in which the colour green reveals its nature: the
green of water, the green of drought, the green of
shadows and light, and that of the moon and the
sun. Thus all subtleties were revealed, for there were
greens which seemed identical, and yet water, when
it touched them, brought out a hidden glow and
revealed them to be entirely different. And these was
the so-called 'rain greens' because they only revealed
themselves in the rain and they retained in each
gradation of colour the memory of all that had
happened on rainy days, but were otherwise hidden
and silent. Because the same things happen differ-
ently on different days, and what happened beneath
the rain can only be recounted and remembered
beneath the rain.

The greens were, therefore, grouped in distinct
classes according to the way in which they revealed
their nature. This, of course, only applied to three of
the methods, since that of drought applied to any
green, because it was not based on a particular cir-
cumstance, but on the life and death of the plant.
There was, then, 'the green of rain, 'the green of
drought', 'the green of shadows' and 'the green of
light', 'sun green' and 'moon green'. Within these
classes there were many subdivisions and parallels
with other classes. This happened, for example, with
the holm oak and the olive, with the poplar and the

cypress. The green of the holm oak was a 'sun green' and that of the olive tree was its complementary green amongst the 'moon greens'. In turn, 'olive green' had its opposite amongst the 'moon greens', which was 'broom green', because they were born during opposing moons. 'Olive green' was born when the moon was high and slow and described a peaceful arc across the dark sky. 'Broom green', on the other hand, was born when the moon was racing, wounded and lustful and howling, like a she-wolf on heat, across a low sky of bright nights, trailing behind it a sour smell and covered occasionally by swift clouds. There was also the underside of leaves to be considered. Thus the green of the poplars that was born in the spring, full of sun and brightness, bore on its underside the memory of the snows.

But one could best get to know greens in their dried form. No one can claim to know the green of a plant until they have seen it dried. And that is how Alfanhuí used the herbalist's shop. Because he could truly know the different greens in what death had left behind. Beneath each green is a dry green, and when the former fades, the latter is revealed. Alfanhuí made comparisons and found that there were greens which were different when alive, but shared the same underlying 'dry green'. And there were greens that darkened in death and greens that became lighter, and others that became brown, red or yellow. And there were even greens so subtle and ephemeral that death left them transparent as slivers of glass. There were some that varied from plant to plant when they were dried because they were so

sensitive to everything going on around them. Occasionally there were capricious patterns of black lines, which revealed themselves as witnesses to unspeakable acts. Sometimes the patterns were sad, like a lament, or angry, demanding vengeance.

In the jars in the shop, Alfanhuí went looking for the mortal mirror of everything alive in order to know it better.

Alfanhuí learned all these things and much more during his time in the house of the graduate, Diego Marcos. But not everything he learned can be set down in this book because only Alfanhuí himself would have been able to write it.

And when he had finished with all this, that strange vegetable gaze left him, and all his memories resurfaced in his eyes.

He bade farewell to his employers and left Palencia because his memory was calling him to the new and beautiful adventure with which this book ends.

XIII

Concerning Alfanhuí's name and his beautiful memory
of his master

Along the road, towards the north, the plateaux
petered out, and the land became golden and undu-
lating. Beneath the sun and a clear, blue sky,
Alfanhuí saw a luminous land of treeless fields of
stubble and more stubble. He saw the beginning of a
dark wood of holm oaks in the middle of a yellow
plain, arrayed like an army before a battle. He saw
the ruins of a monastery with its white stone belfry,
without its bells, on whose crazed, abandoned arches
wood pigeons perched. He saw an ancient, white-
washed village with, on its outskirts, a castle built of
stone the colour of golden earth. Rough, dark green
shrubs sprouted in the cracks. The castle was on a
hill looking out over the river and the plain. There
was an embankment of light earth that ran from the
foot of the castle to the river bank planted with lofty
poplar trees even taller than the embankment. The
river formed islands and sandbanks, and further
upstream you could see the mountains. The sparrow
hawks from the castle tower soared through the sky
above the river.

Alfanhuí went down to the river bank. The water
was greenish-gold in colour. The river lapped against
the banks. It was covered by a light mist. Alfanhuí
saw a large island in the middle of the river, on which

grew osiers and spurge bushes. It was drizzling. Alfanhuí took off his shoes and began crossing the river. The water was very cold, and the river was wide at that point. In the middle, the current was very strong, and large pebbles rolled over his feet. Alfanhuí continued slowly wading across beneath the fine rain. The island had a stony beach and then a small embankment where terra firma began. Alfanhuí stepped up. That place was miles from everywhere. The island must have been less than a mile long by a hundred yards wide. A flock of birds gradually took off one by one and began flying along the island, close to the ground, uttering a sweet, repetitive call. They were stone curlews. Now they were circling Alfanhuí at waist height, about five yards from him:

'Al-fan-huí, al-fan-huí, al-fan-huí.'

They were calling him. Now, all that could be seen was the island and the fine drizzle. It was a light, warm rain that barely seemed to make him wet. Alfanhuí sat down on a rock. The stone curlews landed one by one and then flew off again:

'Al-fan-huí, al-fan-huí, al-fan-huí.'

Alfanhuí remembered his master: 'You have yellow eyes like a stone curlew's.' The stone curlews were repeating his name. Alfanhuí was weeping. 'I'll name you Alfanhuí, because that is the name the stone curlews call to each other.' The rain concealed Alfanhuí's tears as he turned dull eyes to the sweet, simple flight of the stone curlews. There was silence, apart from:

'Al fan huí, al fan-huí, al-fan-huí.'

The mist began to lift. The drizzle became tinged with sunlight that turned it iridescent. The stone curlews were still flying about in the watery light. When the rain stopped, they flew off after the mist. They left gradually, alighting and taking off again, making larger and larger circles. The sky was growing clearer all the time. Alfanhuí saw the stone curlews disappear and with them his name, which hung, silent, in the air. The clouds parted and the sun broke through.

Above his head, Alfanhuí saw the great arc of colours paint itself across the sky.

TRANSLATOR'S ACKNOWLEDGEMENTS

The translator would like to thank Annella McDermott and Ben Sherriff for all their help and advice.

Eastern Arts
Board Funded

When the Whistle Blows – Jack Allen £8.99
The Experience of the Night – Marcel Béalu £8.99
Music, in a Foreign Language – Andrew Crumey £7.99
D'Alembert's Principle – Andrew Crumey £7.99
Pfitz – Andrew Crumey £7.99
The Acts of the Apostates – Geoffrey Farrington £6.99
The Revenants – Geoffrey Farrington £3.95
The Man in Flames – Serge Filippini £10.99
The Book of Nights – Sylvie Germain £8.99
The Book of Tobias – Sylvie Germain £7.99
Days of Anger – Sylvie Germain £8.99
Infinite Possibilities – Sylvie Germain £8.99
The Medusa Child – Sylvie Germain £8.99
Night of Amber – Sylvie Germain £8.99
The Weeping Woman – Sylvie Germain £6.99
The Cat – Pat Gray £6.99
Theodore – Christopher Harris £8.99
The Black Cauldron – William Heinesen £8.99
The Arabian Nightmare – Robert Irwin £6.99
Exquisite Corpse – Robert Irwin £14.99
The Limits of Vision – Robert Irwin £5.99
The Mysteries of Algiers – Robert Irwin £6.99
Prayer-Cushions of the Flesh – Robert Irwin £6.99
Satan Wants Me – Robert Irwin £14.99
The Great Bagarozy – Helmut Krausser £7.99
Primordial Soup – Christine Leunens £7.99
Confessions of a Flesh-Eater – David Madsen £7.99
Memoirs of a Gnostic Dwarf – David Madsen £8.99
Portrait of an Englishman in his Chateau – Mandiargues £7.99
Enigma – Rezvani £8.99
The Architect of Ruins – Herbert Rosendorfer £8.99

Letters Back to Ancient China – Herbert Rosendorfer £9.99
Stefanie – Herbert Rosendorfer £7.99
Zaire – Harry Smart £8.99
Bad to the Bone – James Waddington £7.99
Eroticon – Yoryis Yatromanolakis £8.99
The History of a Vendetta – Yoryis Yatromanolakis £6.99
A Report of a Murder – Yoryis Yatromanolakis £8.99
The Spiritual Meadow – Yoryis Yatromanolakis £8.99